PAINTING ABSTRACTS
Ideas, Projects and Techniques

PAINTING ABSTRACTS
Ideas, Projects and Techniques

Rolina van Vliet

SEARCH PRESS

First published in Great Britain 2008 by Search Press Limited,
Wellwood, North Farm Road, Tunbridge Wells, Kent TN2 3DR

Reprinted 2009

Originally published in Holland as *Ga Abstract 2 De Praktijk* by Arti, Alkmaar
Copyright © Rolina van Vliet

English translation by Cicero Translations Ltd

English translation copyright © Search Press Limited 2008

English edition edited and typeset by GreenGate Publishing Services, Tonbridge

ISBN: 978-1-84448-336-5

Author:
Rolina van Vliet

Illustrations:
Rolina van Vliet
Course members (sources stated)

Photography:
Rolina van Vliet

Original layout and lithography:
Fritz/repro/bv, Almere

Printed in China

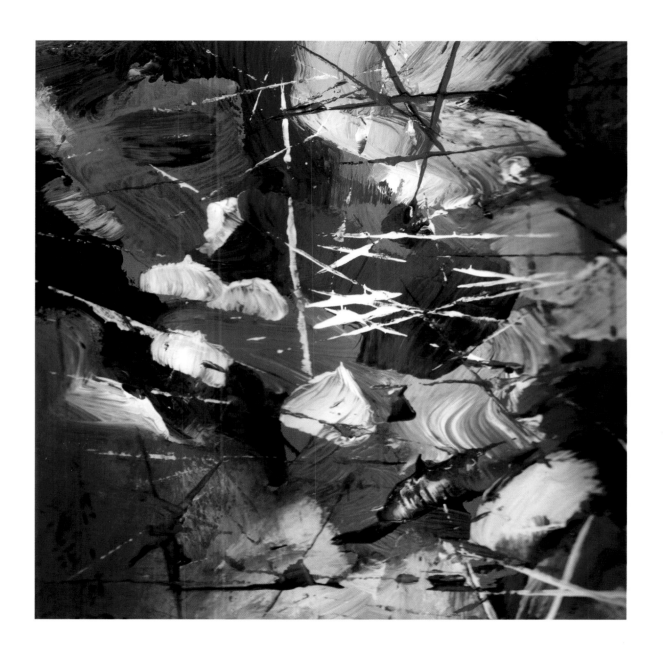

Contents

Dare to paint abstracts, and a whole world opens up in front of you

Take a step forward and choose a way of painting in which everything can be done but nothing has to be. Give yourself freedom and throw out all of the rules.
Learn to use your feeling, fantasy and spontaneity again.
Discover that there is infinitely more than just painting reality.
Experience the fact that self-confidence grows as you learn to accept and appreciate your own contribution.
Enjoy the creative process in which nothing is 'wrong'.
Experience the pure joy of playing with materials, colours, shapes, ideas and design.

Realise that you are able to create something unique entirely by yourself, and experience the essence of free expression.

Understand the abstract artist's method of painting and use of tools.

Come into contact with painting from another range of vision, freely, unconditionally, spontaneously and individually.

Choose abstract; choose freedom; choose yourself ... paint abstract!

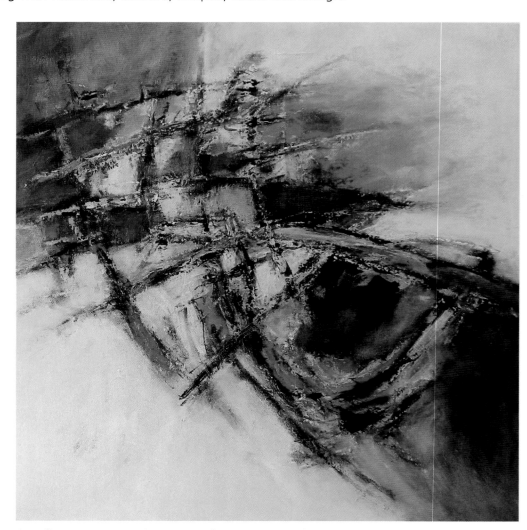

Acrylic on canvas 70 × 70cm (27½ × 27½in)

1. Introduction

Why this book?

Abstract painting, by its expressiveness, fits perfectly into the current age. We are constantly looking for new forms of expression and attach value to freedom of action and innate or natural ingenuity. Nothing else offers the opportunity to satisfy these needs like abstract painting.

Because this is primarily a practical book I have kept the theoretical part as short as possible. I have included basic information relating to picture elements, composition, theme and design, which you need to familiarise yourself with before doing the exercises.

Information on exercises

The book includes a great number of painting exercises to help you learn abstract painting. It does not have any step-by-step examples, since this would inhibit your own creativity and that is just what I want to prevent. The exercises which are described will, however, give you very clear information on method, materials, technique, composition, imagery and structure to help you work in a directed way. Abstract is, after all, not simply 'messing about with paint', on the contrary, it is the basis of painting freely and is the optimal way of best developing your artistic talent.

Home study

When you do the exercises in this book you will really be undertaking a home course in how to paint freely. In short, a book from which you can develop your technique and refer to in the future.

I am very pleased to be able to introduce you to this unique learning method in greater detail. Please accept the challenge and discover what abstract painting can mean for you.

Rolina van Vliet

Acrylic on canvas 70 × 70cm (27½ × 27½in)

5

2. The abstract method of painting

The abstract method of painting

The abstract method is a way of studying in which you consciously get to know about the artist's tools. In standard literature on the subject, learning to paint is mainly approached via subject or theme: how do I paint a landscape or how do I draw a portrait? The abstract method of painting, on the other hand, follows a different route. It approaches painting from the point of view of artistic skills and picture elements, or from that of imagery, with which we can build up, or construct, a painting. Together with paint and materials these form the basic tools of every artist, regardless of his or her style. When you follow the abstract method you first learn how to deal consciously with the different elements of the picture in order to develop your talent and artistic skills further. The stimulus for designing this alternative method was the realisation that qualities such as one's own contribution and artistic appreciation are often neglected. Because of this, many works give the impression of being amateurish, which need not happen if we are less concerned about a satisfactory result and pay more attention to the essential skills and qualities which we require as artists.

An artist's qualities

Which qualities do we need as painters?
We need to have:
A. Technical skills
B. Painting skills
C. Artistic skills
D. Expressive skills.
Together these form the engine of any artistic process regardless of style.
A great number of technical and painting courses are on offer. Artistic skills are seldom specifically included in any teaching programme.

The abstract method of painting is therefore specifically directed towards the activation, stimulation, development and broadening of our artistic qualities or of our internal emotions. To learn to paint from within yourself, from your inner nature, is therefore the first step.

The essence of painting:
Creativity
Expression
Originality
Individuality

The following qualities are indispensable for abstract painting:
A. Creativity
B. Expression
C. Originality
D. Individuality.
These four qualities are essential in order to create art and are therefore also the starting point and the aim of the abstract method of painting. Every aficionado of free painting ought therefore to begin with them. In other words, your target is not to immediately make a magnificent work of art. The aim of your study is to first of all develop your artistic skills, the most important prerequisite in order to be able to arrive at 'art' in the long run.

Abstract is the path to our inner sources

It appears to me that the abstract direction in painting is best achieved by approaching painting as straightforwardly as possible. In abstract painting there is not always a visible subject present. Therefore, no external information is available as there often is in figurative painting. In abstract painting we have to consult ourselves, our inner selves. We are therefore totally dependent on internal information, and automatically invoke our internal sources: our feeling, intuition and imagination. That is where the development of our artistic talent lies.

Abstract alongside figurative

To follow the abstract method of painting does not mean that you only have to paint abstractly; on the contrary. The method and exercises in this book are geared to developing your artistic skills, feeling for colour, feeling for shape, feeling for texture, composition, harmony, etc. The more you activate these skills the better your work will be, even when you paint figuratively. Abstract painting also stimulates the experimental and expressive approach to figurative reality and leads to the creation of something wholly individual and unique.

The range of the abstract approach is so broad that figurative and total abstraction can exist side-by-side without any problems. It is simply a matter of personal preference. I use both approaches in my work, a freedom which I have allowed myself in order to keep alive each form of expression.

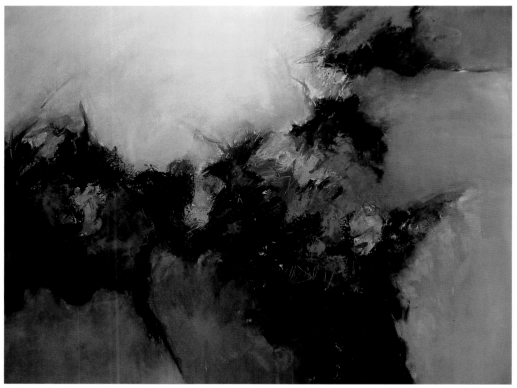

Acrylic on canvas 100 × 120cm (39¼ × 47¼in)

Ten reasons for following the abstract method

1. To work abstractly and learning to abstract is excellently suited to motivating your own creativity and developing your artistic skills.

2. Abstracting is the ideal opportunity not to follow the traditional and accepted, but instead to strike out on a path entirely of your own and to develop your own style.

3. To work abstractly invokes abilities such as feeling, intuition, inventiveness, spontaneity, feeling for shape, colour, composition, harmony, etc. These are all abilities which form the basis of every pure, creative and artistic expression.

4. Even if you do not have any drawing or painting experience you can learn the expressive abstract method without any complicated techniques.

5. Even if you prefer to continue painting reality, abstracting remains the ideal way of reproducing reality according to your own interpretation.

6. To work abstractly allows you to escape from painting 'pictures' or working from examples.

7. Abstract painting paves the way to originality and individuality.

8. Working abstractly stimulates experimentation, discovery, creativity and the activation of your talent.

9. The total freedom of action adds an extra dimension to your experience of painting.

10. In order to make your own judgement, you simply have to try and experience.

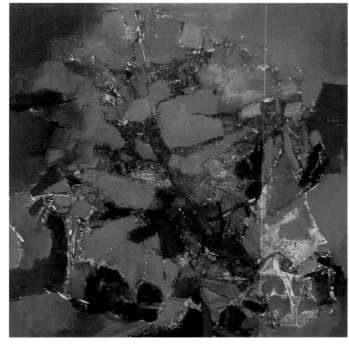

Acrylic on canvas 50 × 50cm (19¾ × 19¾in)

4. What is abstract?

What is abstract?

The dictionary gives the following definition:
Abstract (Lat. abstractus) = removed from reality, free from observation, intangible, not imaginable as shape, not definable as something which actually exists.
To abstract = to derive, separate, remove from observation.

Abstract art is described as art which has no recognisable relationship with visible reality. It uses elements such as shape, colour and line to create its own reality. It is also denoted as non-representative, non-figurative art or art without performance. Abstract can therefore be distantly related to reality because it is derived from it.

Starting point

We acknowledge two starting points in abstract painting:
A. There is a connection with reality.
B. There is no connection with reality.

Abstracting

When we, as abstract painters, start from reality we should first of all use abstracting to make reality more abstract, so that it is scarcely recognisable. It is a method by which we use reality, but do not copy it. It is a more challenging way of reproducing, in an individual way, the things which are around us. Reality then only acts as a motive. We no longer allow ourselves to be dictated by which shape or colour we have to use, but are free to create our own new reality.

From reality to abstraction

When we want to use concrete reality such as a tree, flower or landscape in order to be able to abstract, we can take the following steps:
A. Leave out all detail.
B. Leave out all depth, such as shadow and perspective. Keep to a two-dimensional reproduction.
C. Simplify the shape by composing with rigid, fantastic or jagged lines.
D. Deliberately change the colours to other, unrealistic, colours.
E. Reduce the whole to a few main lines and shapes.
F. Compose an individual, unusual or unnatural, composition.

Finally, so little of the reality will remain that you can comfortably disconnect the subject from its original function. You will have reduced reality to abstract shapes which you can use as the inspiration for your performance, study or painting. There is no way anybody can now recognise in your work anything of the reality from which you started. The way in which you carry out this process will determine whether the work will still be seen as anything recognisable or as abstract. The more you deviate from reality the nearer you will approach total abstraction, the greater your own contribution becomes and the more space there will be for creativity and expression, originality and individuality.

You will also profit from the abstracting method as a figurative painter.

9

5. Our tools

Our tools

Let us open the artist's tool box and have a look at what is in there. Of course we use paint, brushes and so on, but in abstract art the artist's tools include more than we imagine.

We can roughly divide these into a number of primary and secondary picture elements or abstract values. The primary ones are more direct agents, and include the actual ingredients which we use to construct the secondary elements. We can differentiate the following picture elements:

Primary picture elements

PRIMARY
Line
Shape
Size
Colour
Tone
Texture

Composition

COMPOSITION

Secondary picture elements

SECONDARY
Movement and dynamics
Design, rhythm and repetition
Equilibrium and balance
Unity and harmony
Variation and gradation
Dominance and emphasis
Contrast and antithesis
Dimension and depth
Space and division

Every painting is always an arrangement, a structuring, a merging or a composition of parts of these picture elements.

Picture elements, a starting point for study

If we consciously pay attention to these elements in the course of our study we will learn to recognise them and adjust our imagery. The more experience we have with this, the stronger our skills will become, including our feeling for colour, shape, contrast, composition etc. In the long run, we will be able to use these artistic sources of feeling both freely and intuitively. This is also the reason that the picture elements are chosen as the starting point for the study programme in abstract painting.

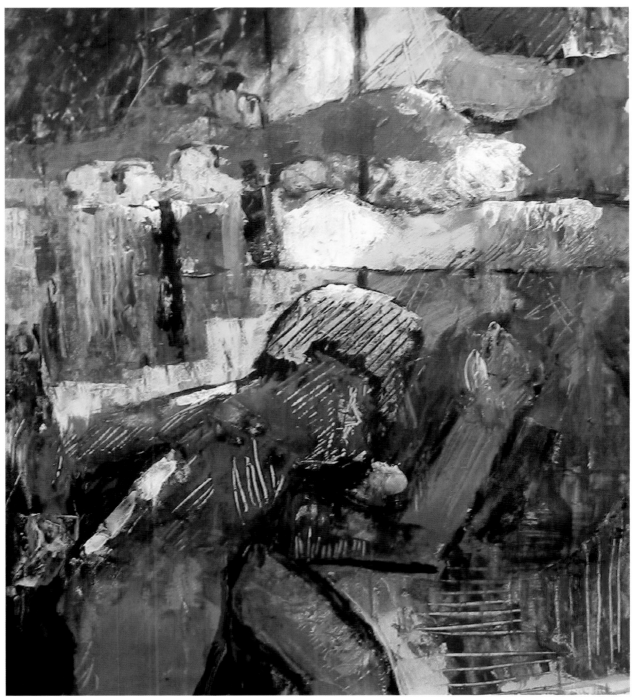

Elaboration of study No. 55. Acrylic on paper 50 × 70cm (19¾ × 27½in) (A. v. d. Wildenburg)

Learning through play

The preferred way of developing our artistic sources is play. Playing is the most open and uninhibited way of gaining experience. As children we know how to use this perfectly, as adults we have sometimes forgotten how to. There is, however, no other single method of practice which activates as many skills as the game. The value of the game as a learning tool, however, has to be adapted as a complete and fully grown method of study. Therefore look at every exercise as a game. Abandon yourself to an intuitively spontaneous process of painting in which investigation, experimentation and healthy curiosity will take you on an uninhibited journey of discovery.

Practice

If you really want to learn to paint I can only advise you of one thing: invest all the time you have in practising. You will probably learn a great deal through simply reading and looking at pictures, but that will not teach you how to paint. Do not expect to become an artist from a maximum of ten lessons, but keep practising and build up as much experience as possible. I can guarantee that you will gain a lot of enjoyment from it.

The correct attitude to work

In order to give practice as fair a chance as possible the correct attitude to work and practice is required. In the meantime here are a few tips:
- Have you adequate motivation – are you itching to start?
- Is the exercise stimulating and inspiring enough?
- Maybe begin with a little 'warming up'.
- It does not have to become anything. It does not need to be anything, it does not need to mean anything and, above all, it does not have to go on the wall immediately! In other words, do not put any especially high demands on yourself.
- Give the free painting process space and allow yourself to be led by feeling and intuition.
- Ensure that there are adequate materials available so that you do not lose the thread and your creativity is not restricted by false economy.
- Look upon every exercise as a thrilling challenge.
- Allow yourself a little fun with water, paint, crayon ... whatever you like, and enjoy it.
- Do not allow yourself to be disturbed and do not ask for a pat on the back from the people at home. We are still busy practising and are not producing art yet.
- Ensure that you have a pleasant place to work, get your material together and get started.

Adventure

In short, play a game, follow your heart and forget everything around you, then study will always become a great adventure.

How do you start on the exercises in this book?

Study information

The exercises in this book follow on directly from the lessons which I have given in my courses and workshops on abstract art over the last ten years. This book allows you to follow these lessons at home.

All the lessons have been designed by me on the basis of the artist's tools: the picture elements, the materials, the technique, the composition, the structure, the theme, etc. That means that I simply link every exercise to one or more of the tools. You should be able to obtain this information fully from the description of the exercises. In this way you will actively learn to know and use your tools.

The exercises

You will obtain information on each exercise as shown below:

Exercise number and main feature of the lesson

The aspect of painting which is emphasised, improved and developed in the lesson is stated here.

Theme/emphasis

This gives the topic of the exercise following the lesson. It is the subject, the idea and/or the starting point of the lesson. This can be playing with line and colour or playing with right angles or circles or playing with water and paint, etc.

Picture elements

Here the most expressive picture elements and artistic concepts which evolve in the lesson are given. We learn to know and use the parts of our imagery and this will develop our feeling for expressive imagery.

Composition

The main features of the relevant composition are given here.

Materials

This includes a summary of the materials which you may need during the lesson. You can always change the materials or add extra materials according to your own ideas.

Techniques

Specific techniques which are used and explained in the lesson are given here.

Work sequence

An important part of every lesson is the structure of the work. Structure is the sequence of the steps you take to give your work a particular effect and aura. You can also deviate from the lesson structure and try out your own variations.

Tips

Here you will find tips relating to your exercise in order to expand your knowledge and experience.

Variation exercise(s)

Elaborating on the lesson, one or more extra teaching exercises are given to widen your experience.

Pictures as illustrations

Pictures

Every lesson is provided with one or more pictures. These images are an illustration of the lesson only. They are not intended for you to copy. As a student artist you have a duty to produce your own work. In other words, you should do the course totally on the basis of your own feeling for colour, shape, composition, etc. Otherwise there is no point in studying! I deliberately do not use the word 'example' because this suggests copying. I do use the word 'illustration' because the aim of the picture(s) is to support the text and to help you to visualise the lesson exercise. In keeping with the philosophy of the abstract method I should have omitted all the pictures from the book in order to give you space for your own creativity and not to influence you in advance. However, a book without images would not be very inspiring to artists who are so visually focused. Nevertheless the students on my courses do in general have to do without illustrations. They are continually directed towards their own journeys of discovery. I advise you to close this book as soon as you start your lesson exercise in order to give your own creativity and expression greater freedom. During the free painting process you should be aware that any illustrations can really confuse you and will not be very good for your spontaneity and your own contribution.

Illustrations

Many of the illustrations in this book originated from students on my courses. They are studies which they made during, or as a result of, the lessons and workshops. The images are individual works of art or details from these, and are the result of numerous short studies specifically made for the exercises to illustrate technique and method.

Developing artistic skills

There is a lot of information to take in in the exercises – but do try to enjoy the learning process. The course exercises are designed to widen your experience in free and abstract painting to the extent that you should be able to develop your artistic feeling for colour, shape, line, texture, composition, harmony – for imagery – and the structure of pictures and, on the basis of this, you should eventually arrive at your own original and expressive work.

Lessons are a starting point

The disadvantage of this kind of teaching method is that you adhere too strictly to it and tend to believe everything is binding. This is emphatically not so.

Therefore look upon every lesson only as a starting point, as a stimulus and initiative to paint. When you have started a lesson and feel like doing something entirely different, allow that to happen; who knows what exciting result will come from it. In other words, always allow room for spontaneity and intuition. You can always start a lesson again. However, if you think that you have to do something different in order to avoid problems, or you feel like escaping, it is better for you to keep to the exercise: the act of solving problems will have a positive effect on your creativity, imagination, inventiveness and perseverance.

Remember the following:

Sequence is arbitrary

- The lessons do not follow any special sequence as regard degree of difficulty. You can start at any of the lessons. Decide what you have in mind and then choose a lesson.
- The lessons vary in length. Some are no more than half an hour, with others you may be busy for a day.

Repeat lessons

- It is wrong to think that after doing a lesson you will have that part of the course under your belt. I strongly advise you to repeat the lessons. Only then will you have acquired the technique, the sequence of work and the respective imagery for yourself. The more you practise a technique the easier it will become and you can then use it instinctively in your paintings.

Make something individual

- Your lesson will more valuable if you are able to create an individual and stunning new work which is not simply a copy of the illustrations in this book. Originality and individuality must always be your starting point.

Study is practice

- All the exercises are aimed to be a practice. Never aim to produce a work of art, but rather a reproduction of your creativity, artistry and originality. Practise communicating expressively, intuitively and spontaneously as an artist.

Level of difficulty

- Some lessons will be difficult, others very simple and easy. This does not take away the fact that every lesson adds something to your experience and development.

Lesson emphasis

- Almost all the lessons acknowledge that a great number of the picture elements do not apply. Rather, the lessons are divided up according to one or more of the picture elements because I just want to use that lesson to emphasise these. That does not mean that the other elements have nothing to do with it, they will also require your attention during the painting process. Therefore, several of the lessons could just as easily have been placed under a different chapter heading. My reason for highlighting a certain element is purely and simply as a lesson emphasis in order to teach you to consciously handle the picture elements, or the artist's tools in the broadest sense.

Healthy self-criticism

- Evaluate your work after every lesson on the basis of the picture elements and aspects of composition referred to in the exercise. This will make you aware of the function and effect of the picture elements. You will therefore learn to consider and analyse your work critically. This will have a positive effect on every spontaneous painting process.

Widen your experience

- Some techniques are repeated in other lessons, mostly with a different emphasis and in combination with something else. Repeating the structure and technique of a work strengthens your experience in the wider sense.

Make room for your own contribution

- Above all, feel free to implement your own ideas and inventiveness in the exercises. This will prevent you from being dependent on the exercises, which is certainly not the aim.

Let us start and find out how it works.

Shape

As an abstract artist we can use both figurative shapes from reality and totally abstract shapes.

Abstract shape language

Abstract shape language

When you achieve complete abstraction you use a shape language which does not represent anything and which can roughly be divided into five groups.

Geometric

1. Geometric shapes. These are rational and are conceived by ourselves. Quadrilaterals, rectangles, circles, etc. form the basis of geometric abstract art, such as in constructivism.

Symbolic

2. Symbolic shapes. These are symbols with a decorative function which is partly linked to a specific meaning. These shapes are also present in cultures where not only art, but also clothing, houses and implements are decorated with traditional symbolic shapes.

Organic

3. Organic shapes. These are free shapes which are present in nature and can be detected visually, but which are only used as an abstract shape. We can discover organic shapes in rock formations, stones, microscopic organisms, growths, etc.

Free

4. Free shapes. This refers to fantastic expressive variable shapes which evolve from a spontaneous painting process, such as in abstract expressionism.

Shapeless

5. Shapelessness. This does not in any way refer to a specific 'closed' shape. It is a sequence of expressive colour nuances and painting effects, mostly arising from the free experimentation with materials and techniques. The act of painting itself creates the intended result. We see this in the work of the material painters, action painting and in colourfield paintings.

Group 1, above, is the most restrained of the five groups; we only achieve maximum freedom in group 5.

Features of shape

There are many features and qualities of the element of shape (or surface) that create opportunities to vary shape. We can therefore conceive of:
- Open or closed shapes.
- Flat and spatial shapes, 2-D and 3-D.
- Static and dynamic shapes.
- Small and large shapes, narrow and wide shapes.
- Light and dark shapes, with varying amounts of contrast.
- Monochrome or polychrome shapes.
- Shapes with smooth or structured upper surfaces.
- Shapes with or without contours.
- Rigidly marked out or free and expressive shapes.
- Separate or overlapping shapes.
- Uniform or variable shapes.
- Transparent or opaque shapes, etc.

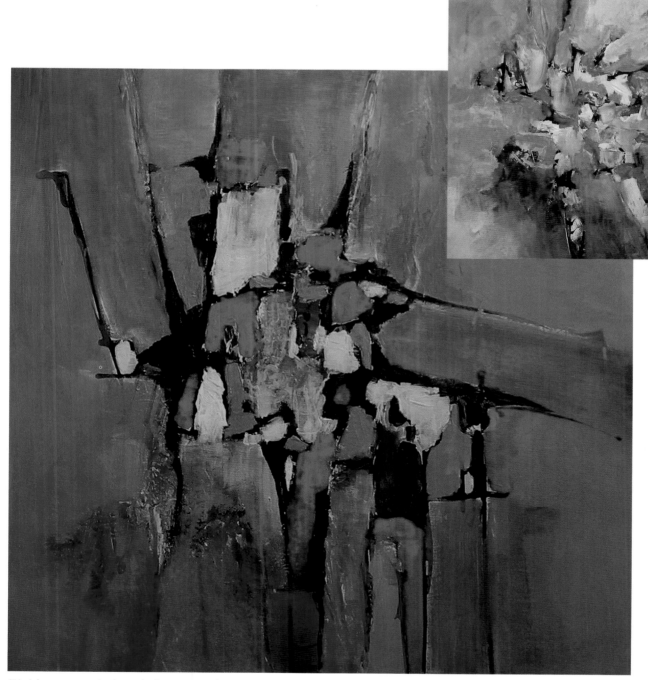

Rigid open and closed shapes with contours (main picture) or something less rigid and expressive (inset)

Exercise 1 Expressive shapes

Theme/ emphasis	Playing with paint, colour and texture.
Picture elements	Line, shape, colour, texture, harmony, unity, dynamics.
Composition	A composition which fills the picture.
Materials	Acrylic paint, palette knife, brush, canvas or stiff acrylic paper.
Technique	Knife technique, painting and mixing on the work.
Work sequence	Design a surface divided by some spontaneous lines. Apply the colours to the canvas roughly with a palette knife. Scratch lines in the wet paint with a stick in order to give extra texture. Continue to paint with the brush in order to round the work off.
Tips	Mixing the colours on the work will be successful only as long as the paint is still wet. During painting feel free to change the shapes by going across the lines of the sketch. This will give spontaneity to the space and work.
Variation exercises	1. Paint free shapes directly on to the canvas with the palette knife, without any previous shape or composition. 2. Repeat the exercise by working only with a large, wide brush. This time use only neutral colours.

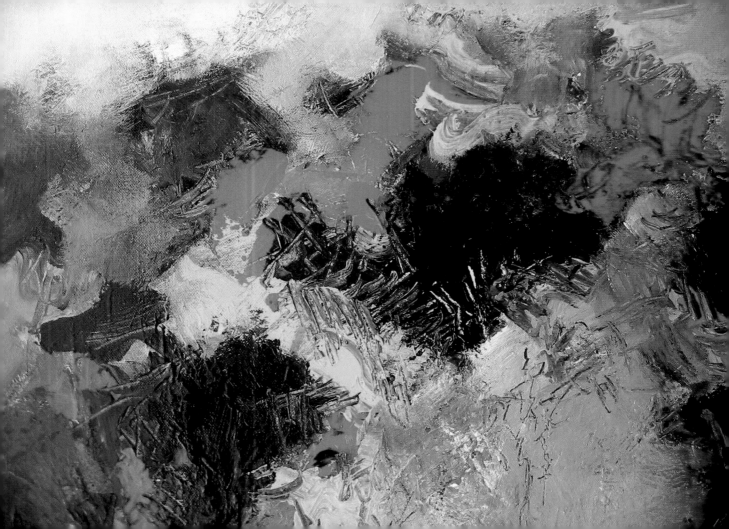

Exercise 2 Variations in shape

Theme/ emphasis	Playing with shape features: large, small, with and without contours.
Picture elements	Line, shape, colour, size, tone, harmony, rhythm, repetition, design, dynamics.
Composition	Use the whole paper for the composition.
Materials	Stiff paper (minimum 300gsm), felt pens, watercolour or acrylic paint.
Technique	Drawing, colouring and painting techniques.
Work sequence	Fill the whole paper with large and small splashes of paint. Draw the contours roughly with a felt pen and vary their size. Apply extra colour emphasis with watercolours.
Tips	Use smaller shapes in the centre and place larger shapes on the outside edge. A similar variation on this size will strengthen the focus of attention in the centre of the composition.

Variation exercises

1. Design a composition with very large shapes and paint it with acrylic paint, without any contours.
2. Start again with a felt pen and make alternating large and small splashes of colour without using a contour line.

Study with felt pen on paper

Study with watercolours and felt pen on paper

Exercise 3 Geometric shapes

Theme/ emphasis	Playing with geometric shapes as a basis for composition.
Picture elements	Line, shape, colour, texture, size, equilibrium, harmony, variation.
Composition	Sketch a balanced composition with rectangular shapes from a central focal point (A). In doing so consider variations in shape and size.
Materials	Acrylic paint, brush, A4 paper.
Technique	Brush technique and the art of leaving blank spaces.
Work sequence	Design the composition on a sheet of A4 paper. Apply a dark underpainting and let it dry. Sketch your design on to the underpainting using charcoal. Paint the rectangular shapes and the remaining space with colours. Always leave a section free between the shapes (the art of leaving blank spaces). The coloured underpainting remains visible in the lines which are left blank (A).
Tips	Geometric shapes, including rectangles, do not need to be exact; the more we play around with them the freer our work will appear to be. It is enough to use the geometric shapes only as a stimulus for our composition (B).
Variation exercises	1. Now design a full image composition (B), and finish painting the work expressively. 2. Now make a study in which the geometric shapes overlap each other and fill up the whole picture (C).

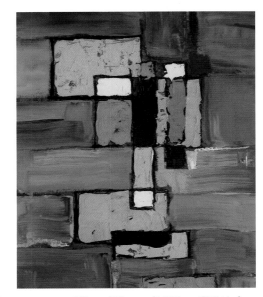

A *Acrylic on paper 50 × 70cm (19¾ × 27½in)*
(A. Stuivenberg)

C

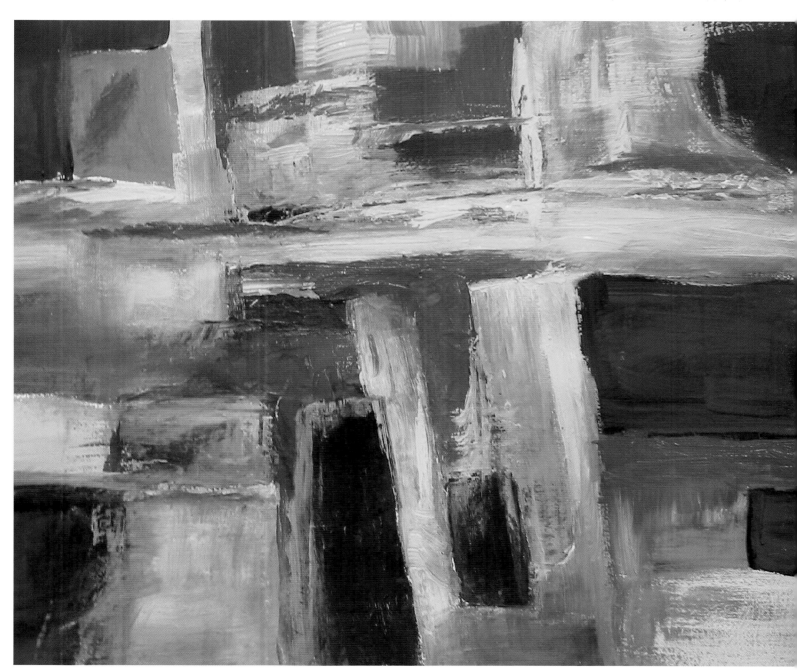

B *Acrylic on paper 50 × 70cm (19¾ × 27½in) (E. Nijland)*

Exercise 4 Free shapes

Theme/ emphasis	Playing with free shapes, colour and texture.
Picture elements	Shape, line, colour, texture, tone, contrast, equilibrium, harmony, dynamics, composition.
Composition	Design a composition to fill the picture in which the lines run up to the edges. There is, therefore, no space left.
Materials	Oil pastel crayon, acrylic paint, brush, acrylic paper.
Technique	Design, crayon and mixing techniques.
Work sequence	Make a scrawling movement on the paper with oil pastel crayon. This type of crayon has a repellent effect on water paint.
	Then make the lines broader by making scraping movements with the crayon (A). Add thin acrylic paint which polishes the paper with an entire colour (C).
Tips	Making a scrawl demands spontaneity. The more rapid your movements the more fantastic the shapes – and that is what we want to achieve. Do not worry about this too much. Use the scrawl as a starting point. Then choose what is or is not important in your composition.
Variation exercises	1. Make two scrawls across each other as the basis for your composition and then first paint out the lines which you do not want to use. As a variation the shapes can now be filled in lightly with crayon. 2. Make a scrawl which fills up the picture. Accentuate the contours and paint the inside of the shapes with clean colours (B).

A *Crayon sketch*

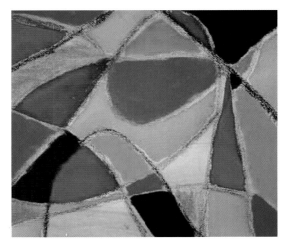

B *Acrylic on paper, detail*

24

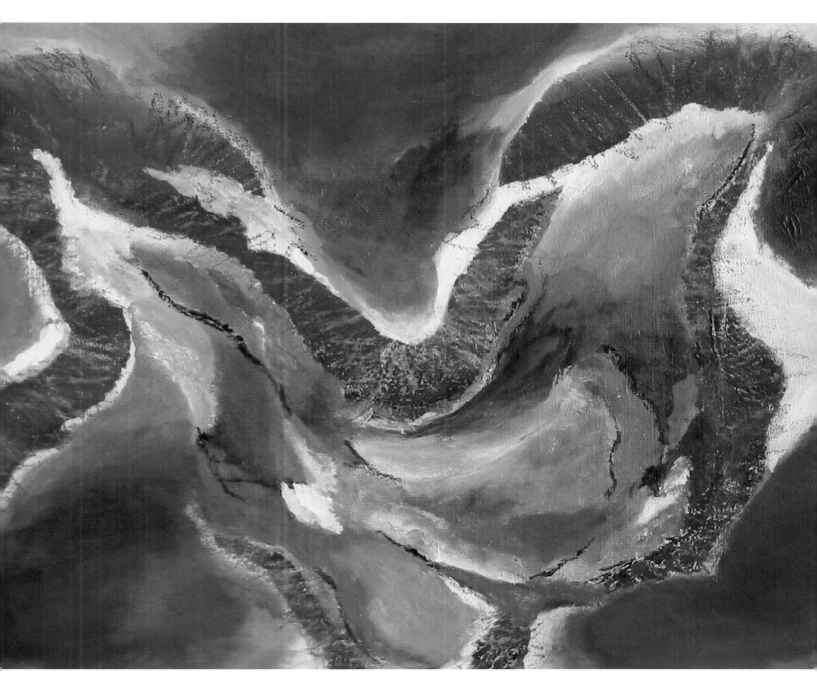

C *Acrylic and oil pastel crayon on paper 50 × 70cm (19¾ × 27½in) (E. Deubel)*

Exercise 5 Spontaneous shapes

Theme/ emphasis	Free experimentation with colour and technique.
Picture elements	Colour, shape, tone, contrast, texture, dynamics, harmony.
Composition	There is no initial composition. The composition will evolve from the different colour fields during the painting.
Materials	Acrylic paint, palette knife, brush, paint canvas or paper.
Technique	Painting in layers.
Work sequence	Start with an underpainting. Let it dry and apply splashes of the next colour. Repeat with a third colour etc. Do not worry about shapes. Let everything happen as spontaneously as possible. The paint can be applied with the palette knife or the brush. If required scratch the paint to create extra texture.
Tips	If you want the colours to mix with each other do not let the bottom layer dry. If you wish to keep the colours pure let them dry completely before you continue. If you want the colour of the underpainting to be seen in the final composition then miss out small sections of the over-layers.
Variation exercises	1. Finally, repeat the study using thin transparent paint. Use the glazing technique so that you can paint layer upon layer. This can also be done very well with watercolours. 2. Make two more studies. First work from light to dark and then from dark to light.

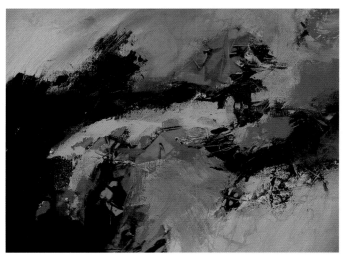

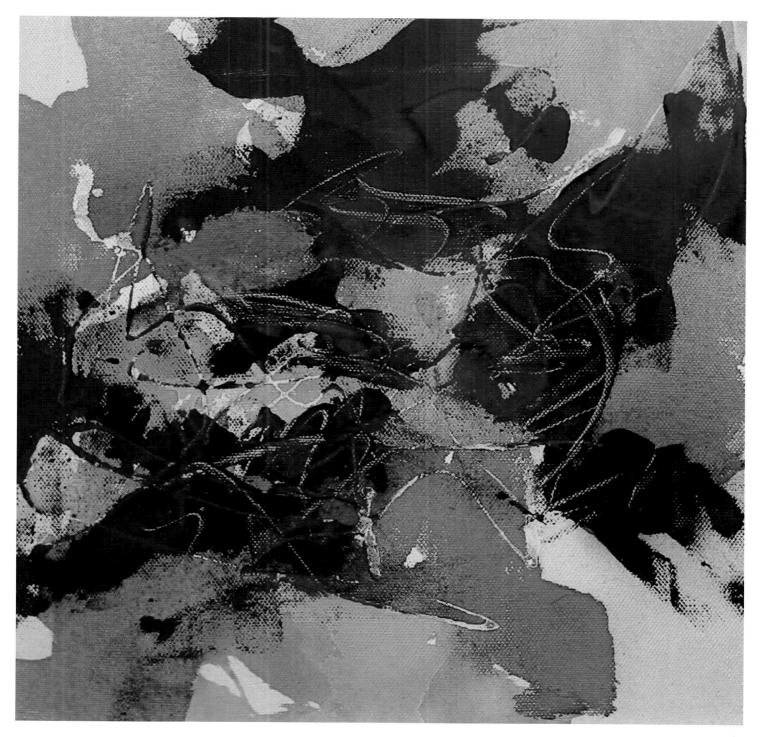

Colour

Source of inspiration

Colour as a picture element is a source of inspiration and expression which we as artists cannot do without. In particular, nine times out of ten the element of colour is the main feature in an abstract work.

For the artist, colour is the real supplier of a sure feeling. Colour brings atmosphere and character to our work. It is important to develop our feeling for colour well.

What you have to know about colour

Primary colours are red, yellow and blue. But there is a variation in the colour red. Depending on the pigments and/or colouring materials used there are some red, yellow and blue colours which vary greatly from each other. Each of these have their own character and give a different result when they are mixed.

Secondary colours are green, purple and orange. They can be bought in pots, but it is more exciting to make them yourself.

Tertiary colours are a mixture of the primary and secondary colours. However, as soon as we let the three primary colours mix with one another we run the risk of producing a mud colour. Nevertheless, with the right pigments and the correct proportions we can make marvellous tertiary colours such as greys and browns.

Black and white are non-colours. The easiest is black from the pot, but it is rather dull and matt. We can make black more lively by mixing it ourselves. To do this use complementary colours with a high pigmentation value.

Opaque colours are covering colours. They cover underlying layers. With some brands it is printed on the pot or tube whether the paint is covering or transparent.

Transparent colours. We need transparent colours for the technique of glazing. If we use them impasto they will cover the underpainting. As soon as the paint is mixed with opaque colours it will lose its transparency.

Analogous colours are colours which are next to each other on the colour chart, for example, red, red-orange, orange. They strengthen aspects such as harmony, unity and calmness.

Monochrome colours are variations within a family of colours. We know the red, blue, yellow, orange, green and purple families. They provide unity and harmony. Just try to paint with different colours of blue and look for variations and combinations. You may possibly add black and white or some of the next colour in the chart.

Complementary colours are additional colours. The complementary colour is the mixture of the remaining primary colours. The complement of red is therefore green (yellow + blue). The complement of yellow is purple (red + blue) and that of blue is orange (red + yellow). Complementary colours strengthen or weaken each other. Complementary surfaces next to each other make the colours more intense. A red surface surrounded by green makes the colours really scream and shout. If, however, we mix or apply the complementary transparent and glazing colours with or over each other they will just weaken one other. The strength of the colour is then impaired and makes the colours more neutral and matt. The use of the complementary function is a powerful way of realising colour intensity and contrast. That is why you should consciously try to use it.

Colour tone value is the strength from light to dark. By lightening a colour with white or by making it dark with black we can allow a variation in tone and contrast to appear. Just try to make your colours lighter or darker with another colour. Colours also mutually have their own tone value or colour value. Yellow, therefore, just *appears* to be lighter than red.

Colour temperature. A colour is referred to as either warm or cold. Their use defines the atmosphere of the work. Almost every colour has a so-called cold and warm variant. In addition to a cold colour, its warm variant has a role to play in creating harmony and variation, and vice versa.

Spatial effect of colour. Cold colours tend to distance themselves from us. Warm colours come nearer to us. Therefore, if we want to achieve depth and dimension we have to take account of this. For example, we could create a warm red foreground and a cold blue background. If we are working abstractly then doing the opposite will give the foreground and background the same status.

Colour domination. We can let a colour dominate by, for example, working with an analogous or monochrome palette or by painting large dominant colour fields. Even a small strong colour surface will dominate as long as the other colours are weak or neutral.

Colour equilibrium and balance. If a colour dominates the eye will automatically seek out the complementary colour in order to redress the balance. The warm colour will look for a cold colour as equilibrium. We can also realise colour balance by using the same colour or tone in the work somewhere else.

Colour harmony and unity can be realised by using analogous and monochrome colours. The use of an underpainting or of a transparent surface paint and broken or repeated colours can also promote colour unity.

Colour contrast gives our work strength and emphasis. We can realise this by using complementary colours. Differences in tone value, the difference between warm and cold colours, smooth and structured colour surfaces, pure and weakened colours, opaque and transparent colours can also provide contrast.

Emotive value of colour has to do with the ambiance or atmosphere a colour evokes. In abstract work the choice of colour is strongly linked to personal emotion and sensitivity.

Pure colours means that we use the colour in its pure state without any mixing with another colour or pigment.

A. The essence of the good use of colour lies in **variation**, **tone value**, **intensity** and **contrast**. Without these aspects the work will lack strength and be flat and meaningless.
B. Mixing colours. Take care that your experience of the various mixing techniques is up to date, and do not limit yourself to 'stirring' colours on the palette.
C. Colour test. This may appear obvious, but I would advise you always to make a colour test first of all. In this way you will avoid unpleasant surprises from occurring in your compositions when you start to work with new colours.

If you use acrylic paint you can mix your colours in the following ways:
A. If you are painting over another dry colour, with the dry-brush technique, broken colours may develop (softening technique).
B. If we apply mildly emphasised colours next to each other, as in pointillism, or if we glaze our colours over each other in thin transparent layers we then use optical colour mixing.
C. As soon as we wipe the colours over each other, the original colours will disappear and together will form a new colour. It is advisable to work as expressively as possible with this and not to 'kill' the colours by mixing.
D. When you are mixing on paper or canvas you must have mastered the technique in order to be able to carry it out as spontaneously as possible.
E. You can also let the colours run into each other wet-on-wet.
F. You can create different colours by polishing colours into each other on the canvas.

Right-hand page. Acrylic on canvas 100 × 100cm (39¼ × 39¼in)

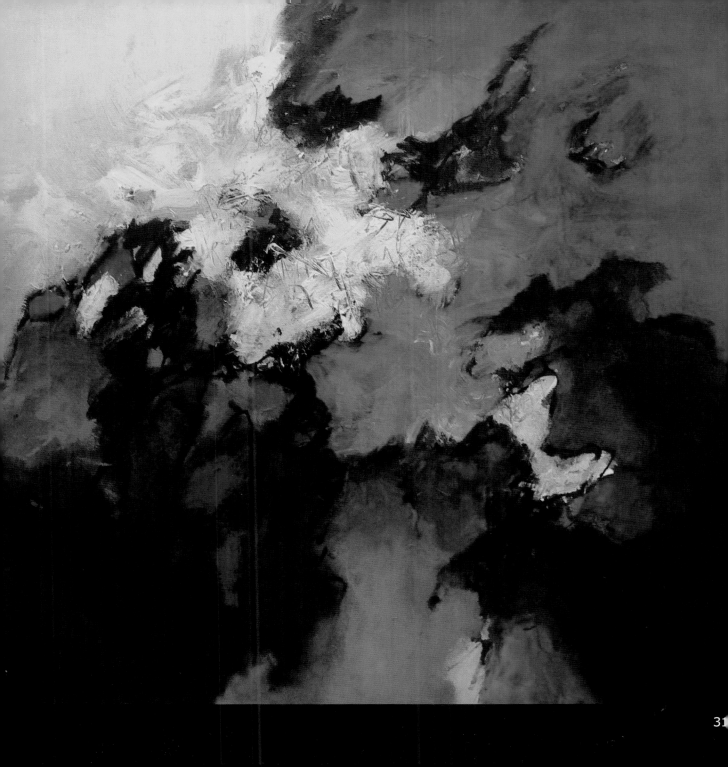

Exercise 6 Mixing with colour blending

Theme/ emphasis	Playing with colour, tone and texture.
Picture elements	Shape, colour, tone, texture, harmony, colour repetition, variation, contrast.
Composition	We do not prepare the composition beforehand, but it evolves by the distribution of colour during the painting process (A).
Materials	Acrylic, palette knife, brush, painting canvas of, for example, 80 × 100cm (31½ × 39¼in).
Technique	Mixing directly on canvas with palette knife and brush.
Work sequence	Begin by applying some large splashes of colour, using two primary colours, next to each other. Then polish the different colours into each other with the brush to produce a mix of colours. To make soft colour transitions add new colours and rub them into each other.
	Repeat the mixing and then add dark colours in order to obtain more contrast. On some places do the mixing with a palette knife; this will give texture.
Tips	The underpainting still has to be wet in order to make mixing possible. Before you begin, carry out a colour test to see what colour results from the colours which you want to mix.
Variation exercises	1. Now do a study in which you use the three primary colours. Try to make colour transitions with the secondary colours. Do not use a brush, but a cloth or sponge to polish the colours into each other. 2. In your next exercise try to mix the colours with a water-based liquid paint (B).

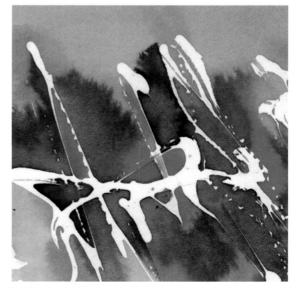

B *Watercolour study*

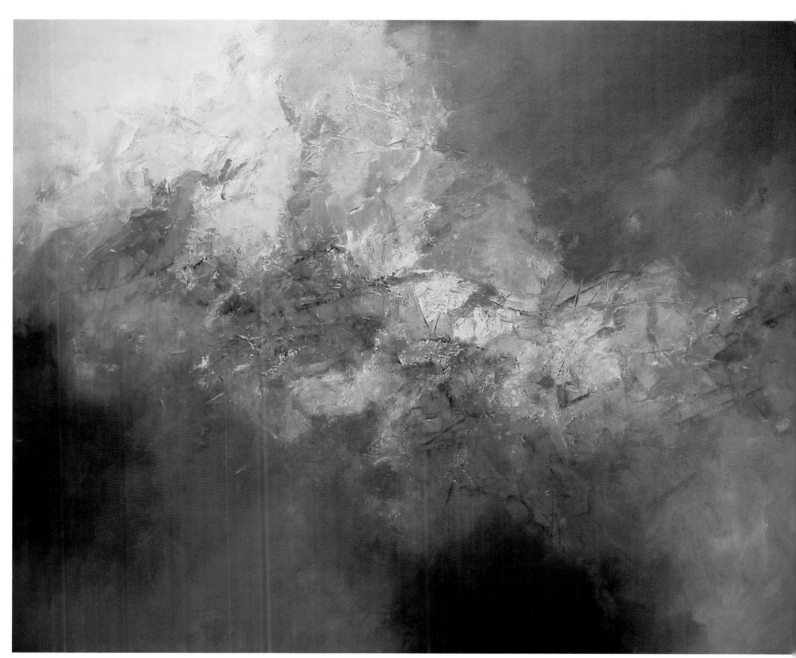

A *Acrylic on canvas 100 × 120cm (39¼ × 47¼in)*

Exercise 7 Mixing with a palette knife

Theme/ emphasis	Playing freely with colour and technique.
Picture elements	Colour, texture, shape, tone, contrast, harmony, repetition, dynamics.
Composition	First of all a simple sketch of dynamic free shapes is made on a piece of paper. This sketch only acts as an aide-memoire and is not transferred to the underpainting – as colour fields might develop on it during painting in complete freedom.
Materials	Acrylic, palette knife, canvas or paper.
Technique	Mixing technique. The colours are applied on to the canvas spontaneously and directly with the palette knife. If the knife is used flatly more equal splashes of colour can be made with thick paint. The paint can be scraped away using the edge of the knife. The tip of the knife can be used to scratch the paint.
Work sequence	Start by applying splashes of colour in red, yellow and blue directly on to the canvas with the knife. Then apply the different colours next to each other with the knife and allow spontaneous colour mixtures to develop. Liven up the dynamics by scraping the colour with the knife. Also try to make calm, smooth sections with the knife.

Tips

Avoid chaos and monotony. The danger of painting with a knife lies in producing too much texture and there being too much of the same movement. Take care that you allow the mixing technique to vary or else it will appear to be rather amateurish.

Variation exercises

1. Mixing colours directly on the canvas or paper can also be done in the next exercise. Lay your canvas or paper flat on a table. Squirt colour directly from the tube or pot and then apply the colours one after the other with the knife or brush.
2. Repeat the exercise with another tool, such as a spoon, fork or credit card, etc.

Exercise 8 Use of pure colour

Theme/ emphasis	Playing with colour.
Picture elements	Shape, colour, tone, size, contrast, harmony, colour repetition, equilibrium, composition.
Composition	A composition with a strong focal point from the centre outwards. The composition has active and passive areas (see composition section). The positive shapes are surrounded by the free remaining space.
Materials	Acrylic, brush, canvas.
Technique	Brush and wet-on-dry techniques.
Work sequence	Design a composition with small shapes around a central focal point. Apply the design to the canvas with the brush and black paint. Let it dry and start with the first colour. Let everything dry again before you continue with the next colour. The colours are mixed on the palette first of all so that no colours are mixed on the work and the colours therefore remain pure. In the final stage you may apply more colours on top in order to increase the harmony.
Tips	Because you always have to wait until the work is dry you may do other work at the same time.
Variation exercises	1. Using the same technique, now do three studies together, in one of which blue should dominate, in the second red and in the third yellow. Of course you will make three different compositions. 2. Repeat the three studies this time using neutral colours in which brown, grey and beige dominate successively.

Acrylic on canvas 50 × 50cm (19¾ × 19¾in)

Acrylic on canvas 50 × 50cm (19¾ × 19¾in)

Exercise 9 Working in black and white

Theme/emphasis

Playing with tone, contrast and composition.

Picture elements

Shape, tone, texture, contrast, equilibrium, composition.

Composition

A full image composition with large shapes.

Materials

Acrylic, broad flat brush, paper or painting canvas; a suitable size is 50 × 60cm (19³⁄₄ × 23¹⁄₂in).

Technique

Brush technique.
Here we allow the rough brushstrokes to stay visible for as long as possible.

Work sequence

With the brush and black paint draw thick lines on the paper so that a free and spontaneous composition results.
Fill in the rest with black and white paint.
Take care that some grey tones are used beside the white and black in order to make the contrast tighter between the black and white.

Tips

In order to allow the brush strokes to be seen clearly you must apply the paint in one stroke and use thick, pure paint. Spontaneous greys will result where you touch white with black.

Variation exercises

1. Now start with a coloured underpainting and repeat the black/white exercise on top of the underpainting.
2. Begin the next exercise with a completely black underpainting and continue with white and grey.

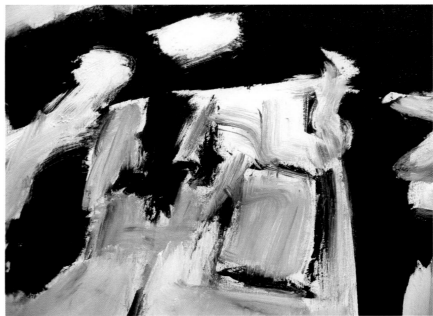

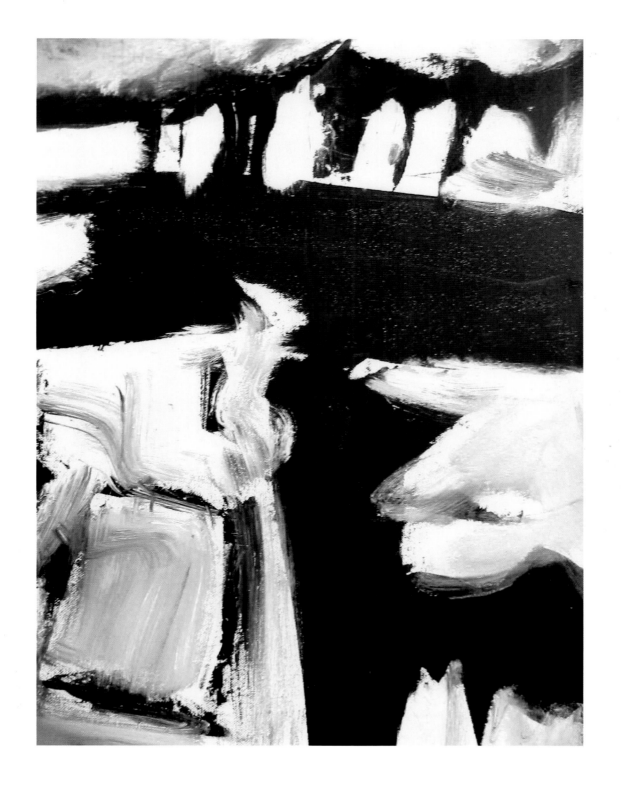

39

Exercise 10 Analogous use of colour

Theme/ emphasis	Playing with shape, colour, tone and composition.
Picture elements	Line, shape, colour, tone, harmony, repetition, equilibrium, dynamics, contrast, variation.
Composition	A composition which fills the picture with shapes which run out from it. The diagonal direction of some shapes will ensure dynamism and movement.
Materials	Acrylic, paper, brush.
Technique	Layered structure and brush techniques.
Work sequence	Start with an underpainting in one colour. Design a composition with shapes which touch the edges and draw them over the dried underpainting. Carry on painting with an analogous colour palette. Leave some space free between the shapes so that the underpainting remains visible in some places.
Tips	If you are working with analogous colours consider using tone and different nuances as much as possible in order to liven up any monotony with contrast and variation.
Variation exercises	1. Now start with a dark underpainting. Use a composition with free shapes and paint the whole of it with pastel tones. 2. Repeat the exercise with a complementary colour palette.

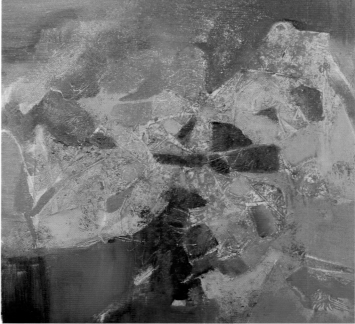

Right-hand page.
Acrylic on paper 50 × 70cm
(19¾ × 27½in) (A. Stuivenberg)

Acrylic on canvas 50 × 50cm (19¾ × 19¾in)

40

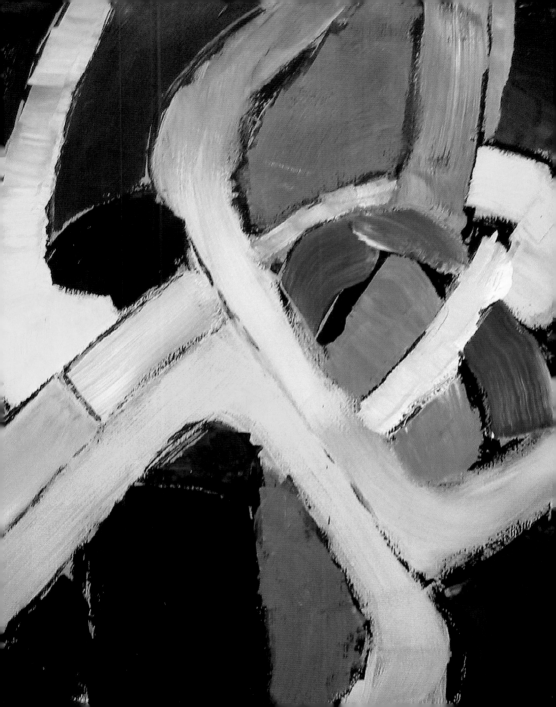

Exercise 11 Use of monochrome colour

Theme/ emphasis	Playing with colour.
Picture elements	Colour, shape, tone, variation, harmony, unity.
Composition	A strong horizontal composition with small shapes to catch the attention and a lot of free space remaining around them.
Materials	Acrylic, brush, canvas.
Technique	Mixing on canvas.
Work sequence	First make a sketch of the composition. Paint the sketch on to the canvas in a dark tone with a broad brush. Continue with monochrome colours. Mix and brush the paint gently on the canvas so that vague nuance transitions result.
Tips	On a monochrome palette it is important to produce as many different nuances as possible. A lot of variation is possible by adding a little of another colour to the mixture. Start, for example, with all the blue colours which you have and also try out combinations of these.
Variation exercises	1. Design a new composition, this time using large shapes and selecting another monochrome palette. 2. In the next exercise concentrate on contrast, using black and white along with the monochrome palette to get a greater tone variation and contrast.

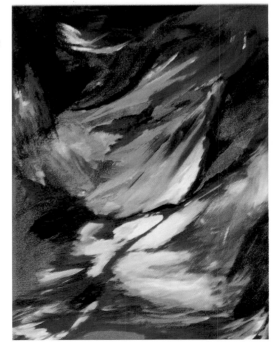

Right-hand page.
Acrylic on canvas 50 × 50cm
(19¾ × 19¾in)

Acrylic on canvas 50 × 70cm
(19¾ × 27½in) (R. v. d. Valk)

42

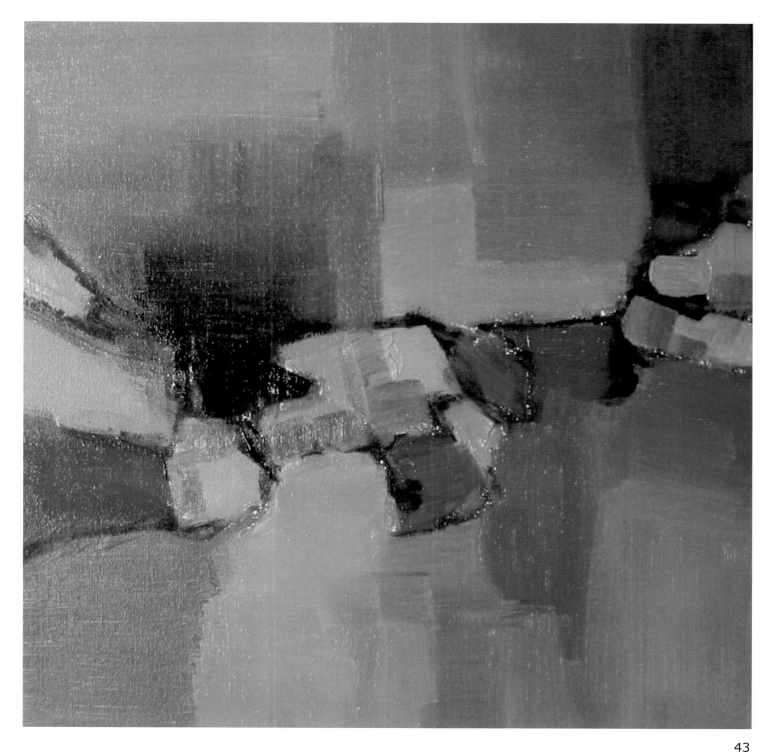

43

Line

The line does not exist

In reality the line does not exist. A tree, apple, house, flower, stone or shape, etc. are not surrounded by a line in reality. We only recognise the transition from one surface to the other. We can show the horizon, for example, by a line, but in reality this is only a visual transition from the surface of the water to the air. The line, therefore, represents only a purely abstract quality.

Element of draughtsmanship

Line as an element is devised by ourselves and only acts as a draughtsman's tool by which we can show shapes, compositions and linear effects on a two-dimensional surface.

Contour

We show the outline of a shape on a flat surface by a line used as an element of draughtsmanship. The resulting contour drawing acts as a support to help us give direction to a painting. The contour enables us to visualise recognisable or abstract shapes and to accentuate shape as a picture element.

Composition element

If we use the line to make surface divisions it only acts as an aid in making up a composition. However, as soon as we use the line expressively it plays a more artistic role and effects the entire character of the composition.

The line as a theme

The line is a very powerful tool within the abstract direction of painting. Many abstract works are exclusively based on line as an element.

You will therefore have to fill up a sheet with linear experiments now and again. In that way you will create your own abstract subjects and get to know the independent value of line as an element.

| The line as a basis for the other picture elements | The line is also important as an aid in generating the other picture elements.
Besides showing **shape** and **size** in contours, the line can deepen **colour** by adjusting shading and translate colour into **tone**.
Linear actions can generate **texture** in many different ways. The line can show direction and so generate **dimension**, **depth**, **dynamics** and **movement**. The line can divide up the surface, but also ensure **coherence**, **unity** and **harmony**.
The line can express **symmetry**, **equilibrium** and **stillness** and play a role in generating **variation**, **rhythm**, **design**, **emphasis and contrast**. |
|---|---|
| Line technique | We can allow lines to develop in different ways.
A. Linear action. Every linear action results in a symbol which we can call a line or stripe, irrespective of colour, direction, length, thickness or the way in which it arose.
B. Linear effects. Lines or stripes can, however, also result without any linear action. There are a great number of techniques which result in stripe-like effects, such as printing techniques, blowing and fluid techniques, template and pouring techniques. |
| Line as a decorative effect | The line can be thick, thin, clear, vague, angular, curved, brittle, dynamic, static, powerful, hesitant, searching, direct, descriptive, interrupted or constant, etc. Experience in variation based on spontaneity is of great importance here, above all in order to enliven a dull, monotonous and mechanical course of a line. Here the line finally begins its expressive way of making the assignment all the more possible for us. |
| The emotional line | The line finally becomes the artist's manuscript lyrically, aggressively, calmly, energetically, emotionally, factually, passionately, frivolously, consciously, unconsciously, spontaneously and intuitively and so reproduces the character, nature, mood and feeling of the artist. It becomes the tool for individuality, expression, spontaneity and originality. |

Exercise 12 The line in hatching technique

Theme/ emphasis	Playing with line, colour and texture.
Picture elements	Line, shape, colour, tone, size, texture, contrast, harmony, composition, dynamics, variation, unity.
Composition	A geometrical composition, with a well-balanced horizontal and vertical emphasis. Use the remaining space as well.
Materials	Smooth Bristol board, coloured pencil, felt pen.
Technique	Colour and hatching technique. Here we make use of materials such as pencil, pen or stylus in order to show lines. By placing the lines closely together it will look like a colour field from a distance. In this way two colours next to each other will appear as a mixed colour (optical mixing).
Work sequence	Carefully design a well-balanced composition with free remaining space (A). Apply a first soft distribution of colour with a coloured pencil. Strengthen the colours by hatching in the same direction. In doing so use the point of the pencil. Repeat this with a second colour. Finally apply a closed, thick coloured surface to some sections.
Tips	Open hatching give a clear stripe effect. Hatching closer together produces a more even surface. Hatching in the same direction gives a calm picture. It strengthens the texture if it is in different directions (B).
Variation exercises	1. Now make a composition with free shapes and with the hatching in different directions. 2. Repeat the exercise without any initial composition and using felt pens (B).

B *Study with felt pen*

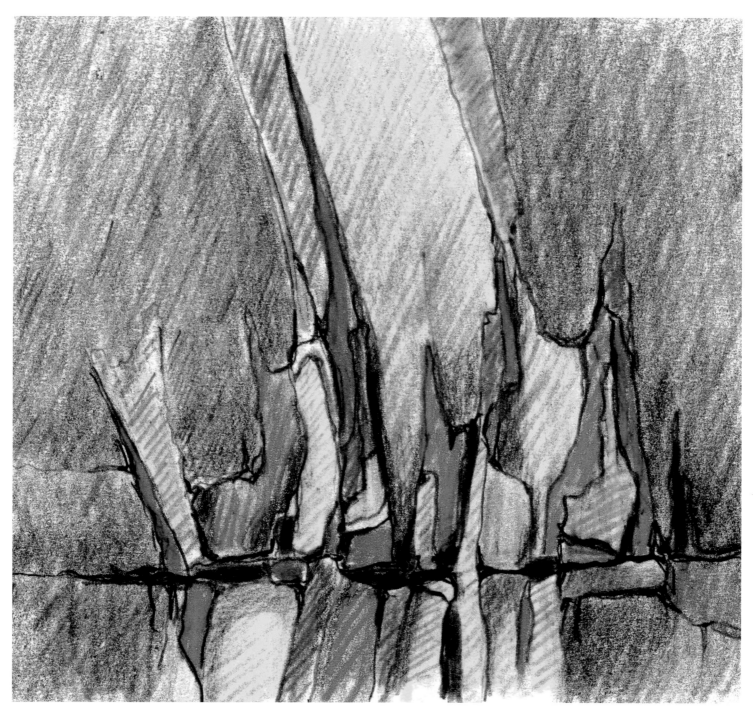

A *Study with coloured pencil*

Exercise 13 Stamped lines

Theme/ emphasis	Playing with line and rhythm.
Picture elements	Line, colour, tone, texture, rhythm, harmony, dynamics, contrast.
Composition	The composition will result from colour and rhythm during painting.
Materials	Acrylic paint, brush, paper, pieces of thick card.
Technique	Line-stamping and rough-brush techniques.
Work sequence	Start with an underpainting in a warm colour and let it dry. Paint with monochrome colours and splash a little on to the paper using the rough-brush technique. Let it dry again. Continue with the stamping technique: press the side edge of a piece of thick cardboard into the colour and use that as a stamp. Go over your work with a rhythmic movement. Vary the direction as much as possible. A similar technique with very thin fine lines gives an extra textured effect. Thin lines will enliven the work and intensify the focal point.
Tips	Use a separate piece of cardboard for each colour. In order to make the lines easily visible go over the dark parts with light colours and the light parts with dark colours.
Variation exercises	1. Start the next exercise with stamped lines first, and after it has dried paint it with glazing and transparent paint. 2. Try to make shapes and designs by stamping and use as the basis for further painting.

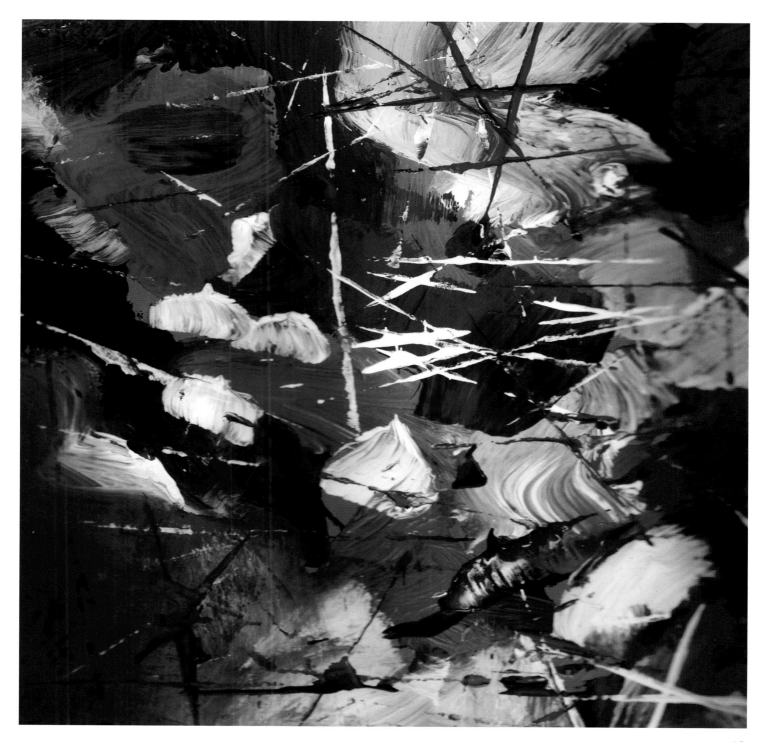

Exercise 14 The line in dripping technique

Theme/ emphasis	Playing with paint, line and water.
Picture elements	Line, colour, shape, tone, texture, harmony, dynamics, variation, contrast, contour.
Composition	Central composition with a recognisable figurative shape, enlivened by the special technique of a spontaneous play of lines.
Materials	Acrylic paint, canvas, brush.
Technique	Dripping and blending techniques.
Work sequence	Sketch the shape on to the canvas with a pencil. Choose as your shape any painting by a well-known painter and use its shape only as a contour. (A painting by Egon Schiele has been used here.) Apply an underpainting using the wet-on-wet technique. Let the very liquid acrylic paint run over the canvas and run into each other spontaneously. After that let it dry. Then apply a contour drawing with a broad brush. If the paint is too watery, some drips and stripes will occur more or less by accident. Add any spots that are still wet as a variation.
Tips	The dripping and blending technique is particularly interesting, as incidental effects can occur. Therefore, do not try consciously to apply a stripe or splash anywhere since there will not be any spontaneity and the technique will lose its charm. This technique and the wet-on-wet technique do really generate surprising effects and are therefore more difficult to control. Accidents do happen. Therefore you must practise frequently.

Variation exercises

1. Start with the wet-on-wet blending technique. Let it dry. Go over it all with the dripping technique. Add spots and then paint out sections with a cover paint. You will then get a completely abstract work in which the texture of stripes and splashes forms the focal point.
2. Make a painting with free shapes. Then add splashes and let drops of watery paint run over it. Now we use the technique for the last layer over the original painting. In this way a rather dull painting can become very surprising.

Right-hand page.
Acrylic on canvas 50 × 60cm (19¾ × 23½in)
(T. Heukelom)

Acrylic on canvas 80 × 80cm (31½ × 31½in)
(S. v. Nostrum)

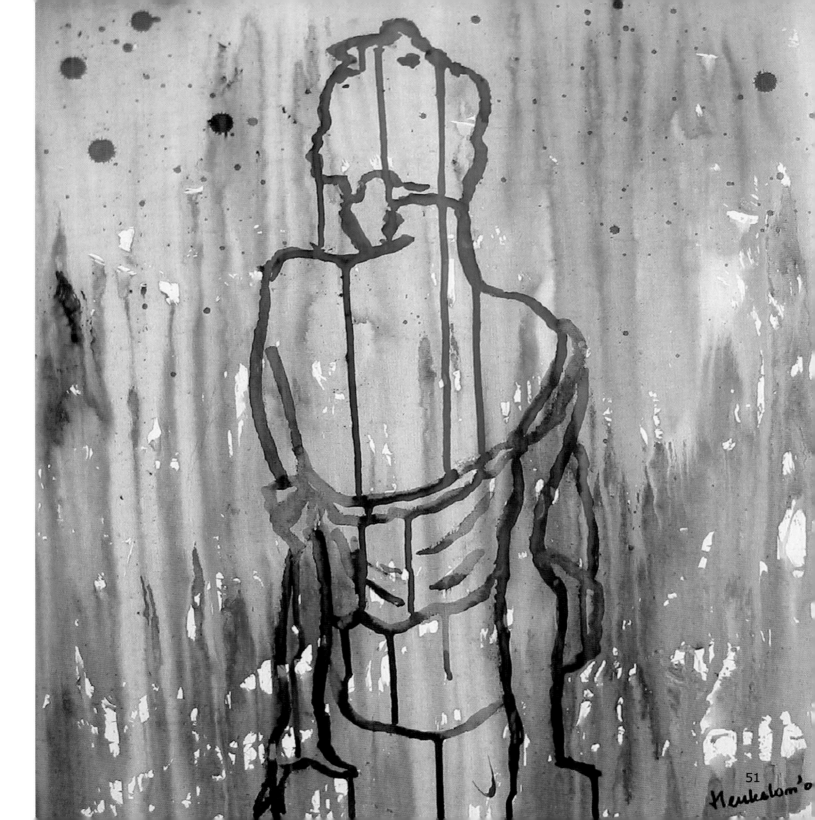

51

Exercise 15 Covering up lines

Theme/ emphasis	Playing with line, colour and shape.
Picture elements	Line, colour, texture, tone, shape, contrast, rhythm, harmony.
Composition	Make a sketch of a composition which fills the picture. The lines of the shapes should touch the edge of the picture so that there is no free space around it.
Materials	Covering fluid, watercolour paint or coloured ink, brushes, watercolour paper; minimum of 300gsm.
Technique	Cover-up and wet-on-wet techniques.
Work sequence	Sketch the composition on to the paper very thinly with a pencil. Cover all lines with covering fluid and let it dry completely. Fill the paper with concentrated watercolour paint and let the colours run into each other spontaneously. Let it dry and wipe off the covering fluid. Continue working according to you own ideas.
Tips	Instead of the covering fluid you can also use candle grease or white or coloured oil pastel crayon. Both repel watercolour paint and cover the paper with a fatty substance.

Variation exercises

1. Start, for example, with a yellow or light blue wash. Then apply covering fluid to the lines and add colour as described above. The lines will now have a colour.
2. The same effect can be obtained by the use of coloured oil pastel crayon on a white or coloured underpainting.
3. Now begin with a polychrome wet-on-wet underpainting. Let it dry and put in the shapes with a removal fluid. Then add colour again and take off the removal film. The lines are now polychrome and give less contrast.

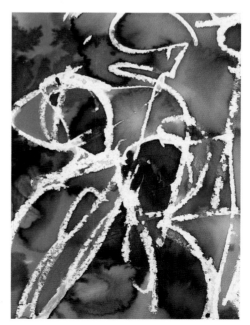

Watercolour on paper, detail

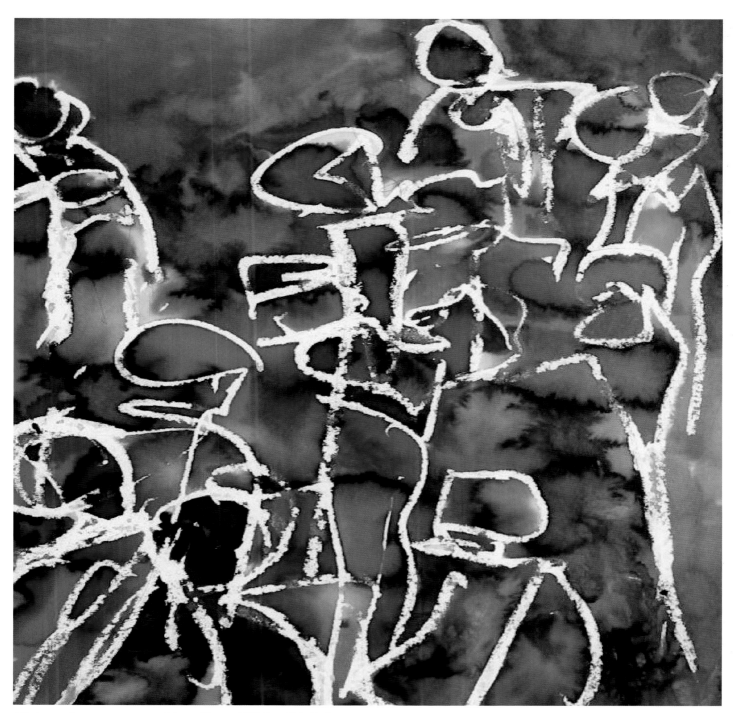

Watercolour on paper 60 × 60cm (23½ × 23½in)

Exercise 16 The line as a divider

Theme/ emphasis

Playing with line and composition.

Picture elements

Line, colour, shape, size, tone, texture, equilibrium, harmony, dynamics, rhythm.

Composition

The play of lines ensures a well-balanced division of the picture surface.

Materials

Canvas, acrylic paint, brushes; or paper, watercolour paper, paint brush.

Technique

Direct smooth technique with acrylic paint and wet-on-wet blending technique with watercolour paint.

Work sequence

First carefully design a well-balanced line composition.
Draw the composition on to the canvas.
Paint in the shapes and mix the colours first on the palette or on the canvas.
Use monochrome colours and look for variations in tone.
Finally finish off by emphasising the contours with a fine paint brush and black paint.

Tips

To paint a surface smoothly it is necessary to pass the brushstrokes over each other, both horizontally and vertically, until the direction of the stroke is no longer visible. This calls for some patience. Several layers of paint are often needed.

Variation exercises

1. Repeat the exercise using a polychrome palette.
2. Carry out the next line composition on paper with watercolour, but create white contour lines by deliberately leaving out sections. Work wet-on-wet so that the colours run into each other.

*Right-hand page.
Acrylic on canvas 30 × 30cm (11¾ × 11¾in)*

Acrylic study on paper

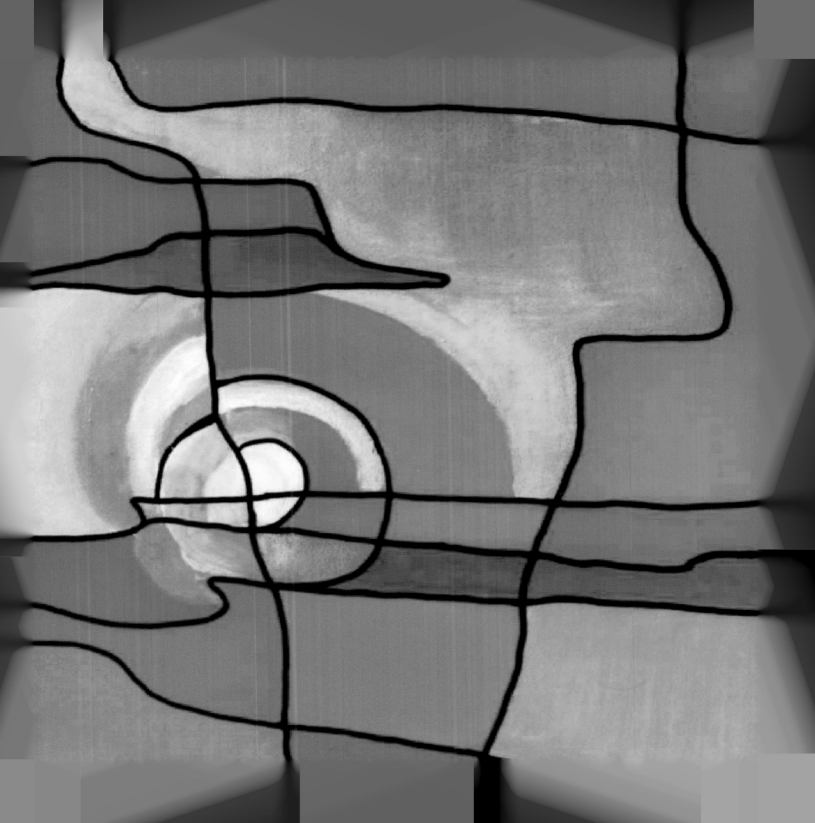

Exercise 17 The poured line

Theme/ emphasis	Playing with line, paint, colour and technique.
Picture elements	Line, shape, colour, texture, contrast, size, composition, harmony, variation, dynamics.
Composition	A dynamic line composition which fills the picture.
Materials	Canvas or acrylic paper, acrylic paint, brush, gesso or gel.
Technique	Line-pouring, blending and rocking techniques.
Work sequence	First design a draft drawing on a sheet of A4. Apply lines in gesso or gel on to the underpainting from a bottle with a thin nozzle. You should really draw the lines crossing over each other and, while doing so, hold the nozzle a little way above the paper. Let the poured line dry. When it is ready, the line will act as a thickening agent on the underpainting. While you continue painting ensure that the lines always hold the paint inside the shapes. Now apply the liquid paint to some of the shapes. Rock the canvas a little back and forth and repeat this with another colour after it has dried a little. Finally paint some sections smooth with a cover paint in the same colour to act as a calming point (A).
Tips	Instead of gesso or gel you can apply the lines with an acrylic medium or acrylic wall paint. Both materials must roughly have the consistency of syrup.

Variation exercises

1. Now begin your exercise holding the nozzle at a greater distance. Act as if you are pouring syrup on to a pancake from a spoon. This way you will get a fantastic play of lines. Paint with a watery blending technique and use cover paint to paint out sections which you want to calm down.
2. Begin with an underpainting in colour. Then apply the play of lines on to it, let it dry and paint out the work with cover paint. The lines will then show the different shapes (B).

B *Acrylic on canvas 50 × 50cm (19¾ × 19¾in) (D. Nijenhuis)*

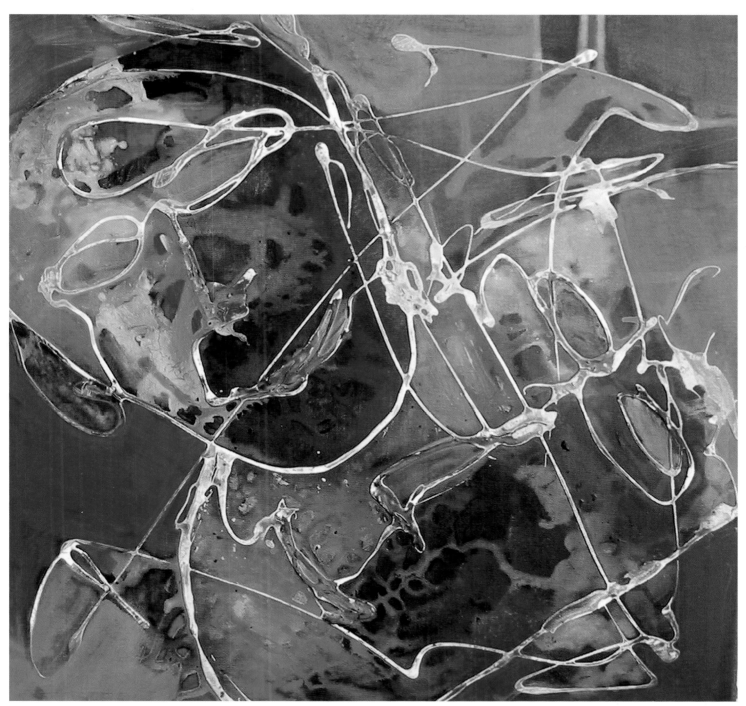

A *Acrylic on canvas 50 × 50cm (19¾ × 19¾in) (R. Arends)*

Tone and size

Tone or value

Strength and weakness of tone determine the power and character of the work. Tone is a picture element that is much underestimated in practice. This results in flat, dull and literally monotonous art which lacks expressive power. The lack of strength of tone and of variation in tone can be resolved simply by being aware of this need. In every work train yourself to use a minimum range of three tones. This applies to both black/white and to colour. In every case check your work for the presence of light, medium and dark tones. You should regularly do tone exercises in pencil or paint with two, three, four or five different tones to build up your experience.

High-key/ low-key

We can produce a painting in which light tones dominate; we call this a 'high-key' effect. The term 'low-key' is used for works with dark tones.

Tone and the other elements

Tone plays a role in equilibrium, balance, variation, gradation, unity, harmony, dominance, emphasis, contrast, opposition and in showing the focal point and the point of attention. Tone as an element also affects the atmosphere and the mood expressed by the work. Tone varies from hard and concise to soft and sensitive. It emphasises the effect of light – sharp or diffuse. Compared to a dark field, a light field will always have the effect of giving light and space. Differences in tone allow us to differentiate shapes from each other and to perceive them separately from each other. We therefore do not need any contours.

Nuances of tone will enliven our work. Besides colour, contrast in tone is the strongest way in which we can show the force of attraction.

Painting with a strong contrast in tone. Acrylic on canvas 70 × 70cm (27½ × 27½in)

Size of the picture surface	We can adjust the primary picture element of size to the dimensions of the support. You can therefore choose a large or simply a small picture surface, narrow or broad, round or, if necessary, triangular, lying or standing.
Size as a picture element	As a pure picture element, size refers to the size of the shapes which are placed on the picture surface; the scale at which the items are shown. You can therefore, for instance, show your subject as very small or as filling the picture. You can also enlarge part of it or reduce it to a microscopic detail.

By size we also think of relative proportions and sections, for example the size of the head with regard to the body or the tree with regard to the hedge. The more proportion deviates from reality the stronger the abstracting effect will be and the greater the visual impact. If you are working totally abstractly you will choose for yourself. The important thing is to be aware of the necessary variation in size. |
| Size and the other elements | Size and shape act as a double unity and affect the secondary elements. In particular, elements such as depth and dimension can be strengthened by reducing or enlarging the size.

Variation, equilibrium, design, rhythm and contrast can also be generated on the basis of size.

However, it is a common mistake not to adjust the variations in shape and size in a composition and therefore this subject merits more of our attention. Specific experimentation with shape and size can help with this. |

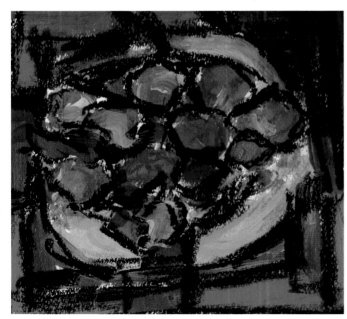

Shapes in a small size

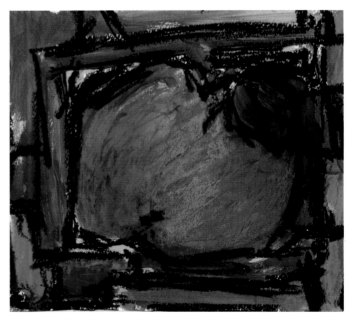

Shapes in a large size

Exercise 18 Painting in high-key

Theme/ emphasis

Playing with tone, light and texture.

Picture elements

Line, shape, texture, tone, composition, equilibrium, dynamics.

Composition

Line composition with a diagonal emphasis.

Materials

MDF panel, gesso, sand, aluminium foil, acrylic paint, charcoal, palette knife, brush.

Technique

Structural technique with filler.

Work sequence

First mark out a simple draft sketch in line.
Prepare the MDF panel by rubbing it and covering with gesso.
Sprinkle some sand on to the gesso while it is still wet.
Work the surface by brushing a palette knife across it in different directions.
Place some pieces of aluminium foil on to the gesso while it is still wet.
Let it dry.
Draw the line composition in with pencil.
Paint it out with a lot of white paint and a bit of colour.

Tips

If you want to put other materials on to the work, such as the aluminium foil here, remember to press down firmly on the whole surface area so that all of the air disappears or else it tends to fall off later.

Variation exercises

1. Make a smooth-textured high-key painting with soft overlapping tones.
2. Make another high-key painting and now use several pastel colours.

Acrylic on MDF panel 30 × 30cm (11¾ × 11¾in)

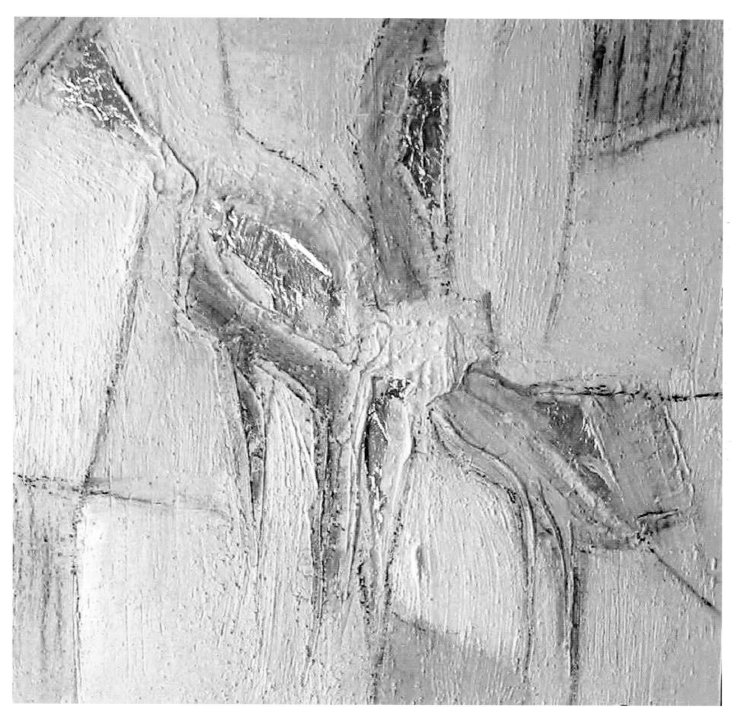

Mixing technique on MDF panel 40 × 40cm (15¾ × 15¾in)

Exercise 19 Painting in low-key

Theme/ emphasis

Playing with tone, colour and composition.

Picture elements

Tone, colour, shape, harmony, dynamics, variation, composition and composition with an emphasis on active and passive.

Composition

A composition with a diagonal emphasis, that has an active area in the upper half and a large passive area in the lower half.

Materials

Canvas, acrylic paint, brush, palette knife.

Technique

Direct a la prima technique.

Work sequence

First mark out a simple draft sketch. Remember the active and passive areas (see Chapter 10 Composition).
Apply a black underpainting on to the canvas. This will ensure that the transparent paint takes on a dark tone.
Let it dry.
Do the sketch on the canvas with white crayon.
Prepare a number of dark colours on the palette by mixing them with, for example, dark blue, brown or a little black.
Then apply the colours directly to the canvas using both the brush and knife.

Tips

It is stated on most tubes and pots whether or not a colour is transparent. If, for example, you are painting transparent ultramarine over a black underpainting, the blue will appear to be almost black. However, if you want to let a little more of the colour be seen add some titanium white, which is a covering colour.

Variation exercises

1. Make a composition that has dark monochrome colours without a black underpainting.
2. Make a composition in which the strength of tone slowly goes from low-key to high-key.

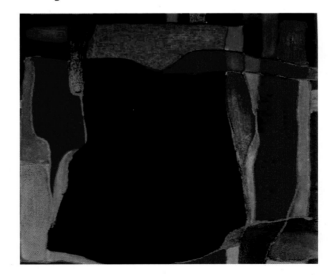

Right-hand page:
Acrylic on canvas 80 × 80cm
(31½ × 31½in)

Acrylic on MDF panel 30 × 30cm
(11¾ × 11¾in)

Exercise 20 Tone variation and contrast

Theme/ emphasis	Playing with tone and contrast.
Picture elements	Tone, colour, texture, contrast, harmony, unity, variation.
Composition	The composition evolves during the painting from texture, colour and tone contrast.
Materials	Canvas, acrylic paint, brush, palette knife.
Technique	Direct technique built-up in layers with pure paint and a palette knife.
Work sequence	Begin with a dark underpainting. Let this dry and decide where the light part is to be and work this with white paint. Then connect the light and dark parts with a number of colours. Unless you do want to show specific shapes it is sufficient to apply the colour in layers using the knife. The greatest contrast will be where the lightest and darkest colours are beside each other.
Tips	In painting with one layer on top of another it always makes sense to let the work dry before applying the next colour. This can help to strengthen contrasts.

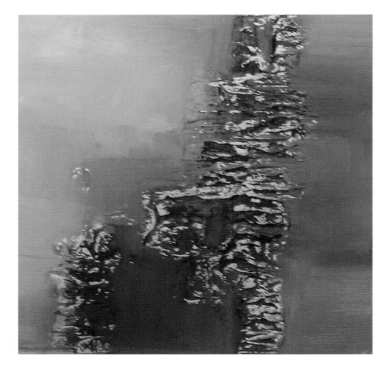

Variation exercises

1. Do an exercise in which there is just a little contrast and difference in tone.
2. Try to do a painting with a lot of contrast but using only black and white.
 Take care that the grey tones join up with these extreme tones.

Right-hand page:
Acrylic on canvas 80 × 80cm
(31½ × 31½in)

Acrylic on canvas 30 × 30cm
(11¾ × 11¾in)

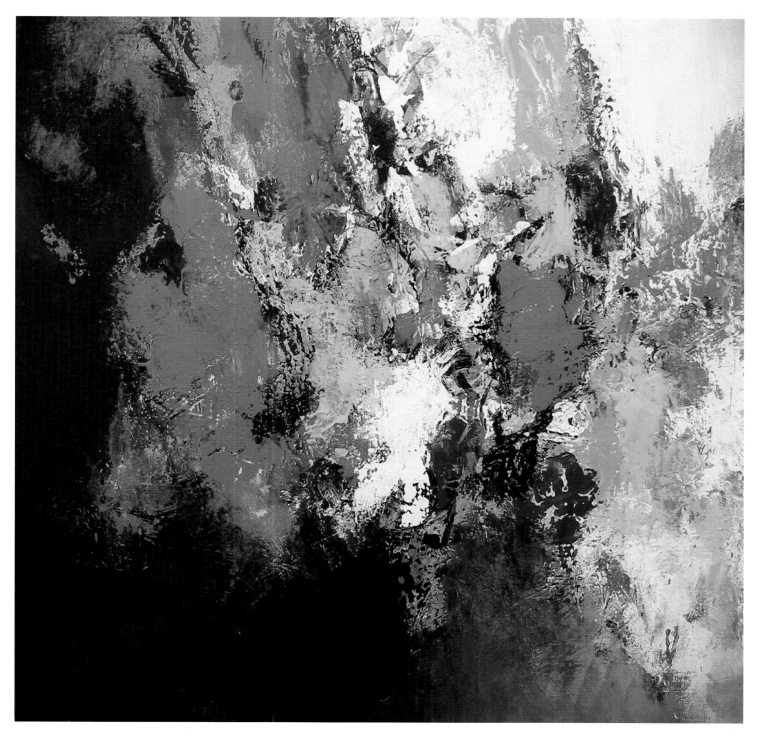

65

Exercise 21 Variation in picture size

Theme/ emphasis	Playing with size and composition.
Picture elements	Line, tone, size, colour, composition.
Composition	The size, and so the dimensions of the canvas or paper, can affect the design of the composition.
Materials	Oil pastel crayon, watercolour paint or thinned acrylic paint, paper or card.
Technique	Wet-on-wet and blending techniques. We can have a mixed technique as long as different materials are used.
Work sequence	Cut different shapes of card. Draw a line composition with oil pastel crayon which you feel will fit the size. Fill the forms with colour using liquid paint.
Tips	Painting on a wholly different size now and again can be inspiring. It gives you new ideas and often surprising compositions result.
Variation exercises	1. From your own work choose two paintings which you should rework on in a totally different size of canvas or paper. If necessary, adjust the composition. 2. Choose two different canvas sizes and use the same composition on both of them.

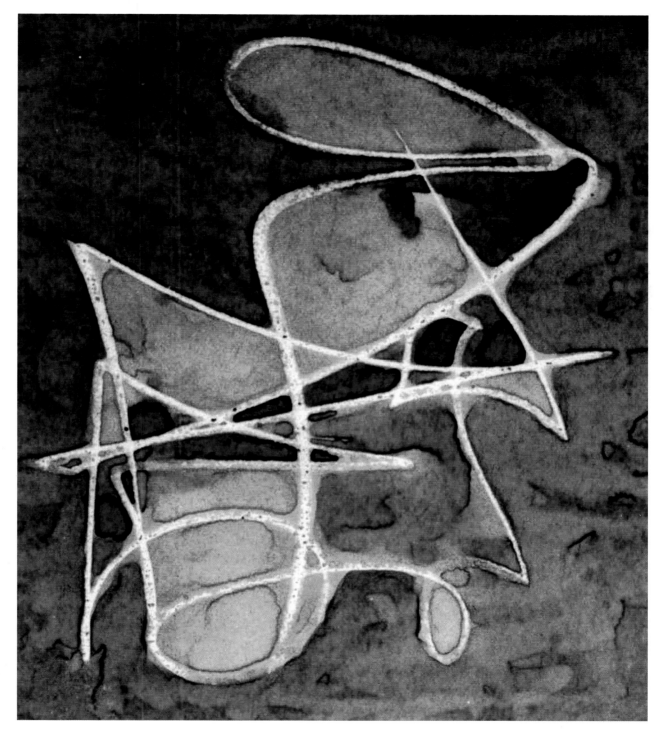

Exercise 22 Size variation as a focus support

Theme/ emphasis	Playing with line, shape and size as a focus intensifier.
Picture elements	Line, shape, colour, size, harmony, dynamics, composition and composition.
Composition	A composition which totally fills the picture, with a central focal point extending to the outside by a difference in size.
Materials	Paper, felt pen, watercolour paint.
Technique	Wet-on-wet and blending techniques.
Work sequence	Carefully design the composition. Make sure that there are differences in size by using large as well as small shapes. If the smaller shapes are at the centre and the larger ones outside, this will create an area of focus at the centre. When the pencil drawing has been added the contour lines should be strengthened with felt pen. Leave a section of white paper between the lines; this will give a sort of mosaic effect. Then fill in the white areas with wet paint using the blending technique.
Tips	Practise the variation in size frequently. The change between large and small shapes gives a composition excitement and really draws attention to it.
Variation exercises	1. Construct a composition with large shapes, all of equal size. Paint it and then continue with a layer of smaller shapes as a focal element. 2. Paint a picture full of rectangles without any preparatory drawing. Work on it by painting small rectangles in and around the focal point.

Study in acrylic

Study in felt pen

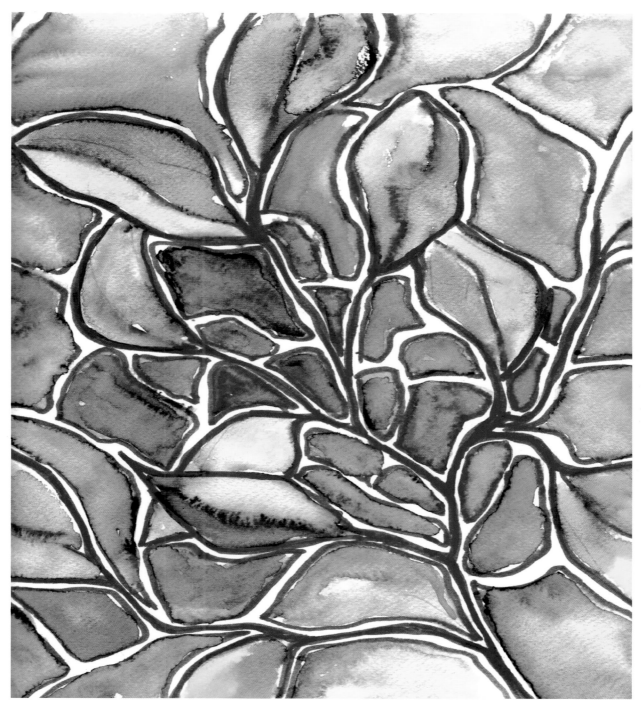

Study in watercolour and felt pen

Texture

What is texture?

By texture we mean all the effects which disturb and penetrate the smooth painting surface. It is the varied layers we use to construct our work. It is everything that we show below, in and on top of our layer of paint. It is how we vary the surface area using irregularities, emphases, rhythms, height, differences or roughness. Texture is a very strong artistic element which determines the picture. Texture is a personal reaction to the material which gives every abstract painting originality and individuality.

What can texture offer us?

It activates imagination, creativity and expression
It initiates experimentation and discovery
It stimulates the discovery of one's own imagery, our artistic vocabulary
It leads to unexpected, interesting and surprising effects
It ensures variation, contrast, emphasis and dynamics
It stimulates painting layer upon layer, which gives rise to depth and dimension
It initiates simplification, abstraction and a freer method of painting
It moves our painting to a higher level of artistry
It makes dull sections active, energetic, lively and exciting
It intensifies the power of attraction of a work
It is a great source of direct inspiration.
If we are able to endow our work with even some of this, we are on the right path.

Tactile achieved by a top layer of sand

Visual with pencil or pastel crayon

Tactile/visual

We differentiate between two types of texture: tactile and visual. In addition, tactile is visual and tangible. It is usually referred to as an extra layer of material which in itself can contribute to the thickness of the relief. An exclusively visual texture is visible but not really tangible, for example, in printing techniques, pencil shading, drip and pouring techniques and effects with salt and similar substances.

Texture how, what, where?

We can apply texture at roughly three different moments during the painting process: A. in advance to the support, B. during painting, or C. after painting over the layer of paint. In all cases the possibilities and effects are also dependent on the qualities of the material which we are using.

A. Texture on the support.

Before we begin to paint our real subject we can apply a specific texture to the support. Some underpaintings already have this. Cloth therefore looks different to a flat MDF and we know of smooth and rough types of paper.

Now, in order to provide the support itself with something exciting, we can carry out the following:
1. Cover the support with, for example, paper, card or textile.
2. Cover the support with a base of structural paste or gesso, to which we can add fillers such as sand or sawdust. Depending on the filler we can contribute to the thickness of the relief ourselves.
3. Work on the support with a layer of paint or gesso which can be scratched, scraped or pressed on to produce designs, lines and shapes before drying. This allows us to give the support a specific roughness in advance which, after hardening, will affect the rest of the painting process.

B. Texture in the layer of paint.

As soon as we begin to paint we can add more texture. This means that we are carrying out activity in the paint while it is still wet.
1. Adding, for example, water, salt, sand, lime or chlorine.
2. Working in a varied way with a brush, knife, roller, sponge or spatula.
3. Pressing, scratching stamping and making the paint rough by using foil, paper, sponge, comb, plastic, etc.

C. Texture on top of the work.

Finally, we can enliven our work further by applying texture to dry painting with everything that can be effective for this, such as pressing with stamps, wads of paper, textile, corrugated cardboard or lumps of plastic.

Double texture – on the base and in the top impasto layer

Exercise 23 Texture techniques

Theme/ emphasis	Experimenting with texture and technique.
Picture elements	Line, shape, colour, texture, contrast, composition, repetition, design, rhythm.
Composition	The composition evolves arbitrarily during the texture technique.
Materials	Cardboard, acrylic paint, filler, palette knife, brush.
Technique	Knife, scraping and scratching techniques.
Work sequence	Pour the paint directly on to the paper. Distribute the paint over the whole paper with the palette knife. Scrape parts of the paint off with the side of the knife so that the white underpainting appears through it. Scratch some shapes and contours into the wet paint with the point of the knife. Add some colour. Then repeat with a third colour and add filler to the paint. Now spread the thickened paint across the underpainting with a spatula in order to produce more shapes.
Tips	You can also use texture paste, marble powder or sand as a filler.
Variation exercises	1. Now start with a layer of white paint into which sand has been mixed. Scrape and scratch the underpainting with a spatula and let it dry. Then paint over it with watery paint. The texture of the white underpainting will then become clearly visible. 2. Repeat the exercise with a totally different colour combination and this time use sawdust as a filler.

Exercise 24 Texture in mixed technique

Theme/ emphasis

Playing with shape, colour and texture.

Picture elements

Line, shape, colour, texture, tone, contrast, equilibrium, harmony, composition, variation.

Composition

Two wholly independent compositions placed one on top of the other.

Materials

Canvas, acrylic paint, texture paste, palette knife, brush, A4 sheet.

Technique

Texture, knife and drawing techniques.

Work sequence

First sketch the colour composition and the line composition on a sheet of A4.
Cover some parts of the canvas with granular texture paste.
Let it dry.
Paint the colour composition over it with some splashes of wet paint.
With a brush draw the line composition in very fluid black paint over the wet work while it is still a bit wet.
Complete it with a final layer of paint.

Tips

In order to keep the colours pure and bright next to each other the paint must not be too wet and the colour fields must therefore be more or less defined.
In addition, if the paint is lightly wiped over, the white textured parts of the underpainting will often remain visible.

Variation exercises

1. Repeat the exercise but now scratch clear shapes into the texture layer. Then paint out with watery paint. The paint will now subside into the scratched lines and so become visible.
2. Repeat the exercise, but now add another layer of paint to the end, which is lightly wiped across the texture so that a lot of the underlying colour is still visible.

Mixed detail technique

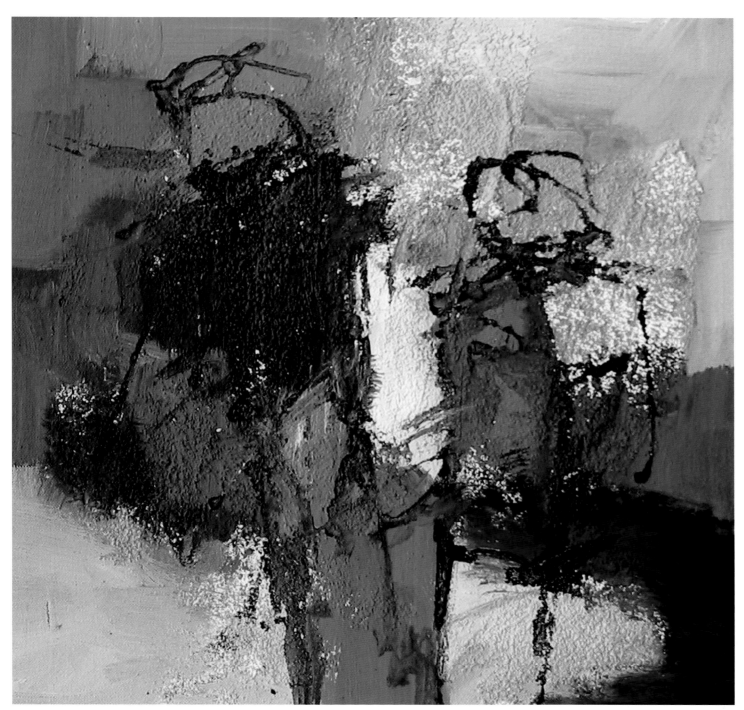

Mixed technique on canvas 50 × 50cm (19¾ × 19¾in)

Exercise 25 Texture with different materials

Theme/ emphasis	Playing with texture.
Picture elements	Line, colour, texture, dynamics, harmony, rhythm, repetition.
Composition	The composition evolves during the experiment.
Materials	Paper, watercolour paint, coloured pencil, oil pastel chalk, acrylic paint, brush, crepe paper.
Technique	Wash, scraping, chalk and stamping techniques.
Work sequence	Free experimentation is a good practice that allows you to try out the effect of different materials. Composition, shapes or composition are not so important for this exercise. Start with a thin watercolour wash letting the colours run into each other. Continue by scraping over sections of the dry watercolour underpainting with a coloured pencil. Now apply colour emphasis here and there using acrylic paint. Then add texture by using the side and the tip of the oil pastel chalk. Finally, you can print by stamping all over the work with a crumpled piece of paper which has been pressed into acrylic paint.
Tips	Let the whole work dry thoroughly. In order to find out the texture effect of a specific treatment or of a specific material it is sensible to carry out a few tests. Keep them together in a folder. This way you can build up your own reference on texture effects and techniques.

Variation exercises

1. Place three sheets of paper next to each other. Use a different material on each sheet and change the order of the work described above. Also use different colours.
2. Carry out the next texture exercise by stamping over different printed subjects layer by layer with a different colour.

Oil pastel chalk on paper

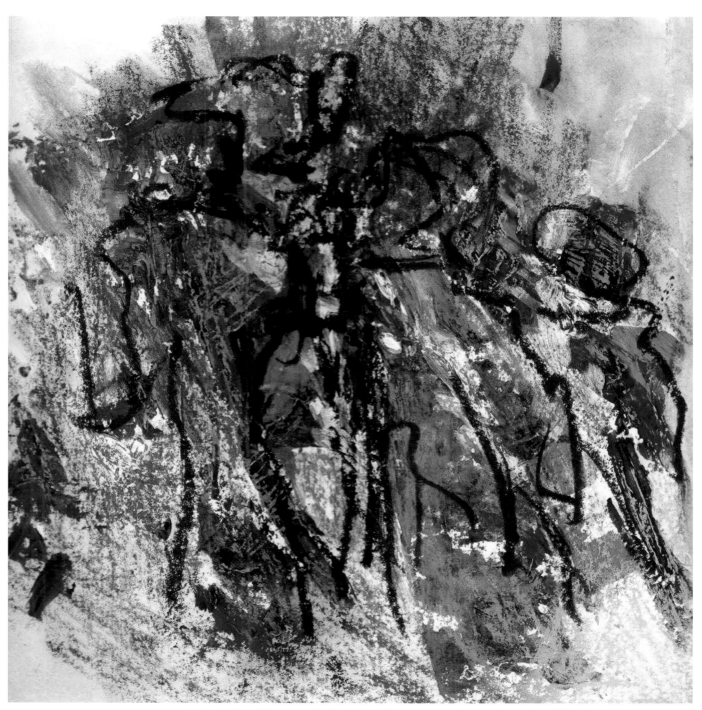

Mixed technique on paper 40 × 40cm (15¾ × 15¾in)

Exercise 26 Texture with gel

Theme/ emphasis	Playing with material, texture and colour.
Picture elements	Colour, line, texture, contrast, harmony, dynamics, dimension.
Composition	No preliminary composition is drawn, but a specific composition model is chosen in which there is room for active areas and passive areas (see Chapter 10 Composition). This time choose a horizontal active area leaving space for passive areas above and below.
Materials	Paper or canvas, gel, acrylic paint, palette knife, brush.
Technique	Knife, scraping and softening techniques. In the last technique brush a dry paint over the underpainting using a dry brush so that the underlying layers of colour can still be seen.
Work sequence	Begin by applying gel to the underpainting using a palette knife. With the knife make some scratches in order to increase the texture. Let it dry thoroughly. Continue painting with paint and brush. Initially use some liquid paint to go over the texture layer. Let it dry again and continue with paint and colour. Complete it with the softening technique.
Tips	Gel has the quality of drying transparently. It is available in smooth or matt and in various thicknesses. The heavier it is the more you can build up a true relief. This is called a tactile texture.
Variation exercises	1. Apply an underpainting in a brighter colour. Apply a thick layer of gel and let it dry. Then continue with a glazing technique using transparent paint. The colour of the underpainting will play a part in this. 2. You can also mix the gel with the paint. In your next exercise try using a spatula freely on your work.

Study with gel on canvas

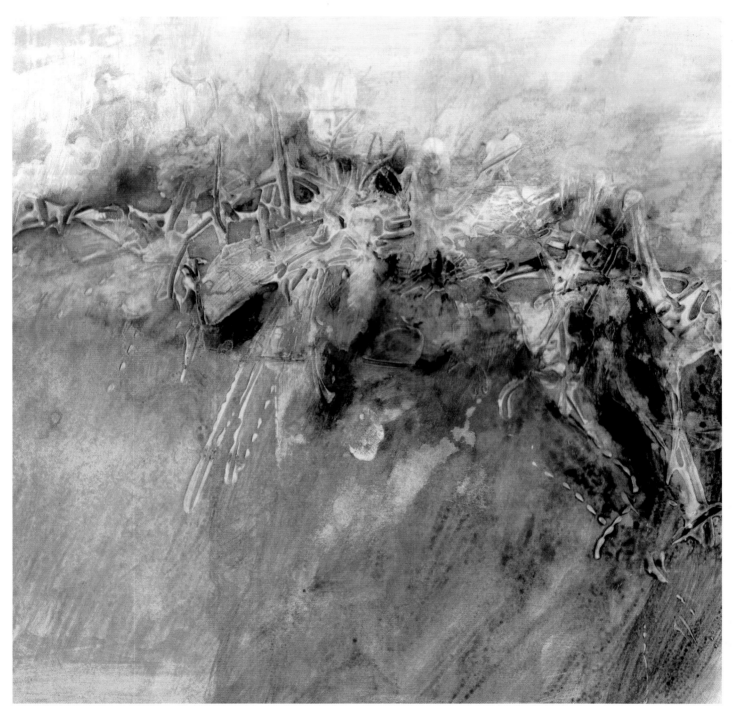

Mixed technique on paper 40 × 40cm (15¾ × 15¾in)

Exercise 27 Relief texture

Theme/ emphasis	Playing with texture and filler.
Picture elements	Line, shape, texture, colour, composition, contrast, rhythm, design, repetition, depth, composition.
Composition	Free composition with the emphasis on rhythm in line and shape.
Materials	MDF panel, plaster, acrylic paint, gesso, brush, filler knife.
Technique	Spatter technique using a filler knife.
Work sequence	Scrape the MDF panel and cover with gesso. Mix paint or gesso with a quantity of plaster to make a thick mixture. Apply this to the hard underpainting with a filler knife or spatula. Form a thick relief layer on your panel and work the surface through by pressing or scratching lines into it. Leave some parts free as well. Let it dry. Continue with colour.
Tips	Plaster becomes rock-hard very quickly, therefore work quickly if you are using plaster. You can also build up a relief using heavy body gel and modelling paste.
Variation exercises	1. Repeat the exercise with a totally different composition and a polychrome treatment. 2. Build up a rhythmic relief with other materials, for example, thin sticks.

80

9. Secondary picture elements

The secondary elements

The secondary picture elements: movement, design, equilibrium, unity, variation, dominance, contrast, dimension and space, are generated by the primary elements. The secondary elements affect the composition, power and meaning of the work. What secondary elements we use are important to us. How do I achieve unity as a whole and where does the emphasis lie? This appears to be complicated, but learning to use the secondary elements can help us to understand this.

Movement and dynamics

Movement and dynamics refer to direction, vivacity, energy and action. In fact, movement is the visual continuation of one place after the other. Movement determines the route and speed with which the eye tracks the painting. It leads the eye into, through and out of the painting.

If the emphasis is put on the horizontal plane the work will appear to be calmer than if the emphasis is on the diagonal plane. Vertical emphases accentuate stability. Diagonal implies energy. Repetitions in rhythm also generate movement because our eyes follow the rhythm and jump from shape to shape. Even a short rhythmic brushstroke will appear active.

Design, rhythm and repetition

Design, rhythm and repetition point to shapes, lines and textures which are repeated in different areas of a painting and so form rhythmic repetitions. They accentuate movement and dynamics, but also unity and coherence. Different techniques such as printing, scraping and stencil techniques are very effective in showing rhythm and design. Rhythmic movements also encourage spontaneity and a freer method of painting.

Equilibrium and balance

A composition must always have a surface division at the point of equilibirium – a painting is seldom dominant on one side. Symmetry is the absolute form of equilibrium (static equilibrium). As soon as different shapes are added, a new equilibrium is created. A large heavy shape on the right will demand several less heavy shapes on the left (dynamic equilibrium). The more shapes there are in the picture the more complex the visual equilibrium will be.

Balance is not only a question of visual weight, but it also refers to equilibrium in tone, colour and texture. Repetitions are essential to create equilibrium.

Unity and harmony

Unity and harmony are on the whole an excellent way of generating order and coherence of shapes, lines, colours and textures. This is not easy and it demands a lot of experience in order to develop an intuitive feeling for unity. You have to feel that everything has its place, and does not need anything else to be added to or taken away from it.

Emphases and repetitions which connect are important means of generating coherence. Colour, too, can be a connecting factor in glazing the entire work, for example using a single colour. We have to learn the art of creating diversity and unity together so that they appear to be one entity.

Variation and gradation	A lack of variation is one of the most frequent faults. This is fatal above all else in relation to abstract painting. Variation and gradation remind us that a painting requires more than simply just the same shapes, colours, emphases and composition. From time to time we need to develop a new imagery in order to avoid monotony and a lack of meaning in our work. There is nothing as dull as a work in which the same brushstroke or structure is used from beginning to end.
Dominance	Dominance influences a painting's power of attraction. It differentiates the main theme from the minor ones. It determines what the most important factor is and allows that to dominate by means of colour, shape, line and structure. Dominance can refer to the focal point in a composition, but it can also refer to the work as a whole. Domination is also a factor when a large area has been created in a dominant colour but which does not demand very much attention. Dominance is a tool to help you choose emphasis.
Contrast and opposition	Contrast is excitement, attention, dynamics, action and tension. Any painting tending to be monotonous can be livened up by using contrast. Contrast can develop in all possible ways. Contrast is the difference between being meaningless and having great meaning. Too much contrast can, on the other hand, result in restlessness. We need contrast to enable us to express our focal point. Contrast depends on a specific opposition, such as action versus rest, large versus small, a lot or little, light or dark. Contrast develops by means of the primary elements. Contrast calls for attention and cannot be avoided. Contrast makes us step into a painting, wander around in it and then return from it.
Dimension and depth (three-dimensional)	Dimension has to do with depth, our work often seems two- or three-dimensional. Is it flat or does it seem to be more than that? There are a number of possibilities for us to create depth: geometric line perspective, shape and size perspective, foreground versus background, colour perspective, atmospheric perspective, overlapping, etc. It is obvious that if we do not want depth we have to avoid the effects referred to above. In abstract work in general we try as much as possible to avoid depth which is related to the reproduction of reality. Effects of depth which evolve due to texture can probably be adjusted.
Space and composition (two-dimensional)	Depending on the way in which we have divided up the picture surface, a work can give us the idea of space. Smaller shapes surrounded by a large, low, free field suggest a lot of space, rest and silence. Objects which fill the picture do not give much information as to whether there is or is not any more space. A colour structure from dark to light intensifies the spatial effect. Lines which lead us towards the edge of the picture surface suggest space outside it. Closed shapes and areas shut themselves off from any more space. There is therefore an interior and an exterior. A composition with loose shapes gives every shape a separate space, but loses any coherence. Shapes which touch each other or overlap suppress the effect of space. Compositions may have a lot of residual space or simply a little. Space should also be shown as positive or negative space, as subject versus residual space and/or emptiness.

Exercise 28 Dynamics

Theme/ emphasis

Playing with composition and dynamics.

Picture elements

Shape, colour, line, composition, contrast, variation, gradation, equilibrium, harmony.

Composition

A dynamic composition. The diagonal direction intensifies the effect of movement.

Materials

80 × 100cm (31½ × 39¼in) canvas, acrylic paint, large brush.

Technique

Expressive painting technique.

Work sequence

Make a preliminary draft sketch in chalk in which the emphasis is in the diagonal direction, in order to create a dynamic composition.
Start to apply the draft sketch to the canvas with a large brush and black paint.
Then paint the work in colour with expressive strokes.
Mix the colours on the canvas as spontaneously as possible.
A part of the basic sketch will disappear during the painting because you are painting over it. Just let that happen, your design will be more dynamic and expressive because of it.

Tips

Use one brush for each colour; this will make it easier to work quickly and spontaneously.

Variation exercises

1. Repeat the exercise with quite different colours and this time only use a painting knife, for the basic sketch as well.
2. Do a short exercise in which the dynamics evolve due to a strongly visible brushstroke in different directions.

Right-hand page.
Acrylic on canvas 100 × 120cm
(39¼ × 47¼in)

Study in rough brush technique

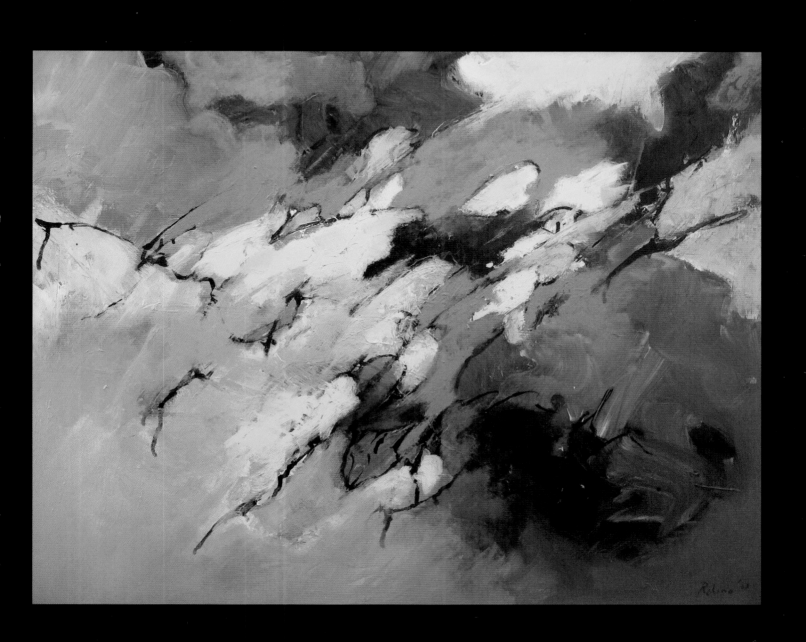

Exercise 29 Balance and equilibrium

**Theme/
emphasis**

Playing with line, colour and composition.

**Picture
elements**

Line, shape, colour, tone, balance, equilibrium, harmony, unity, variation, contrast.

Composition

Horizontal and vertical lines form the basis of the composition so that it is a matter of balance.

Materials

Paper or canvas, acrylic paint, watercolour paint, brush, fine paint brush.

Technique

A smooth painting technique.

Work sequence

To achieve a well-balanced composition with a balance between horizontal and vertical lines and shapes requires a well thought out preliminary sketch.
Draw the sketch in pencil on to your paper or canvas.
Paint in the colour fields by area. Mix on the palette and on the work.
Accentuate the contours of the coloured areas with a fine paint brush and a contrasting colour.

Tips

You can also start your work the other way round. In which case apply the strong contours first and then paint the colour fields.

**Variation
exercises**

1. Place three sheets of paper next to each other and design a different composition on each of them using mainly horizontal and vertical lines. Paint the contours with acrylic paint and then the rest with thin watercolour paint, wet-on-wet.
2. Design a well-balanced composition and paint it with an expressive, dynamic brushstroke.

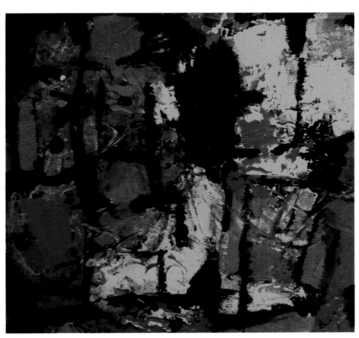

Acrylic on canvas 30 × 30cm (11¾ × 11¾in)

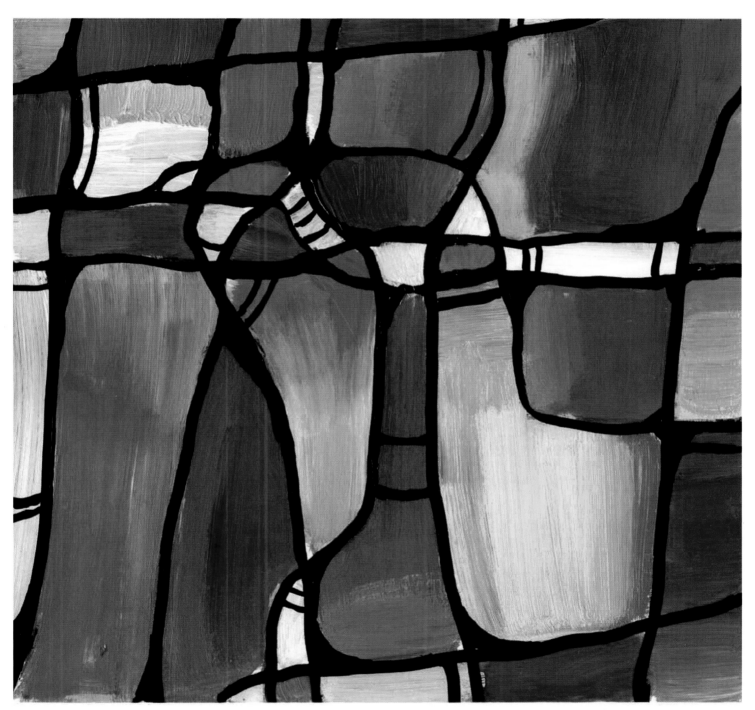

Acrylic on canvas 30 × 30cm (11¾ × 11¾in)

Exercise 30 Rhythm, design and repetition

Theme/ emphasis	Playing with line, colour and rhythm.
Picture elements	Line, colour, shape, texture, size, composition, rhythm, design, repetition, equilibrium.
Composition	A central composition with a strong active focal area created by using rhythmic variations in shape.
Materials	Structured paper, oil pastel chalk.
Technique	Chalk technique.
Work sequence	Make a number of draft sketches with the emphasis on the rhythmic repetition of a specific shape. Choose one design and put a contour sketch of it down on paper. Work on it using the coloured chalk and 'mix' the colours on the paper. Use both the side and the tip of the oil pastel chalk.
Tips	When you gently rub over rough paper with chalk, the dimples in the paper will remain white, so intensifying the texture effect.
Variation exercises	1. Repeat a similar exercise with acrylic paint and use a painting knife as a tool. 2. Paint a polychrome underpainting in acrylic and stamp rhythmic shapes across it with a blunt object. This object could, for example, be a piece of rubber, a button or a cork, etc.

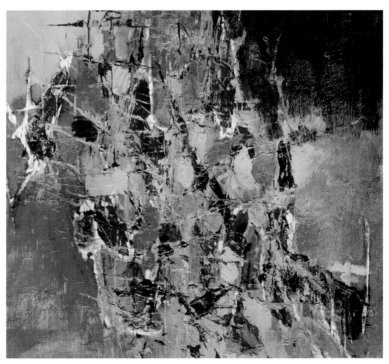

Study in acrylic on paper

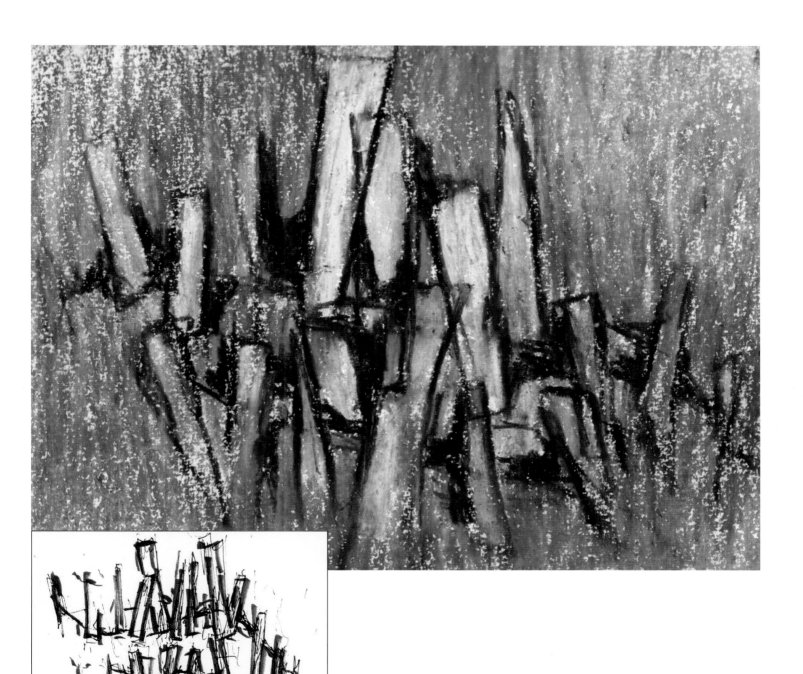

Study in oil pastel chalk on paper

Exercise 31 Contrast

Theme/ emphasis	Playing with colour and contrast.
Picture elements	Colour, shape, tone, size, contrast, light, harmony, variation, composition, dynamics.
Composition	The composition evolves during the painting process with a strong emphasis on contrast and shape.
Materials	Canvas or paper, acrylic paint, brush.
Technique	Free and direct a la prima painting techniques.
Work sequence	Start to paint with thick paint on the canvas or paper without any preliminary drawing. Consider where the light parts appear and where the dark paint should be put next. Mix on the work and try to get variation in colour. Let the work dry in the interim and apply some more colour touches in order to intensify the focal area with small shapes.
Tips	Harmony will evolve if you repeat this elsewhere in the work with specific colours. My own habit is to wipe my brush off at other places on the work before beginning with another colour. In this way colour repetition evolves by itself and you get an interesting distribution of colour.

Variation exercises

1. This is a great exercise allowing you to explore your own range of colours and to discover how you can achieve contrast with green, yellow, red, blue, etc. Always repeat the exercise with another main colour and use black and white to build up a dark and light contrast which is strong in tone.
2. In the next exercise use complementary colours to intensify the contrast. This time also accentuate contrast in shape by consciously using large or small rectangular shapes etc., one after the other.
3. Now do an exercise with contrast in texture.

Acrylic on canvas 50 × 50cm (19¾ × 19¾in)
(W. Jukkema)

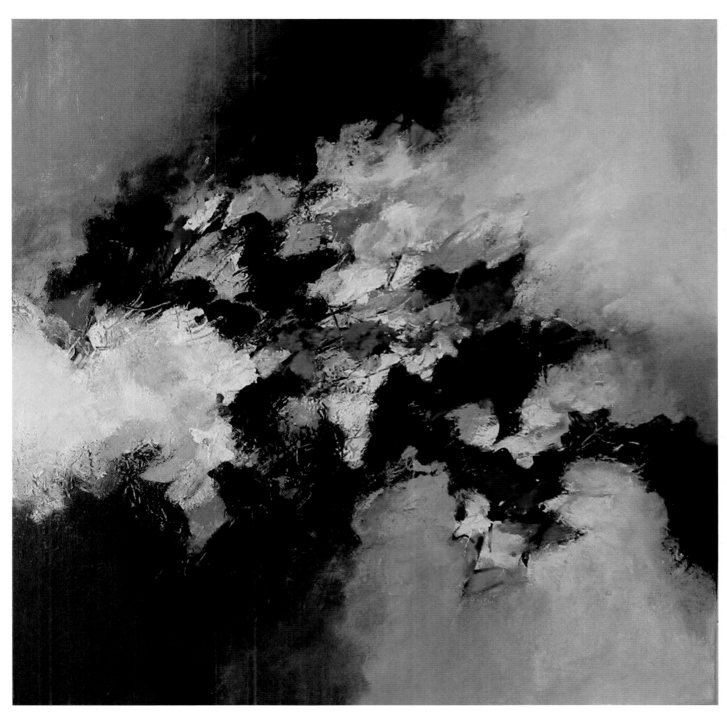

Acrylic on canvas 80 × 80cm (31½ × 31½in)

10. Composition

Arrangement starting point

Composition is the arrangement and classification of the picture elements which together form our imagery. The composition is the framework, the starting point for our painting process. The evolutionary framework of a composition ranges from direct and intense spontaneity to thought out construction and consideration.

Good composition

A good composition has a clear tension and equilibrium based on a specific opposition and contrast. There is an excitement that something is happening, that there is a specific action. Factors such as direction, dynamics and emphasis all have a part to play. We know that our primary and secondary picture elements can support this. It is useful in our painting to pay special attention to:

A. Focal point
B. Active and passive
C. Surface division and types of composition
D. Foreground and background.

Focal point

The focal point is the part of our theme which we give our full attention and emphasis to in our picture. We can give emphasis by the way in which we use size, colour, tone, line, texture or shape. This means that we emphasise other parts less. The focal point is not a free-standing picture. It is accompanied by links and secondary focal points so that coherence and unity evolve. Lines which lead in and out have a crucial role to play. These are purely suggestive lines which lead our eye to the focal point and to the other emphases in our picture. These lines are absolutely necessary for a focal point. Without these lines our eye would land abruptly on the strongest point and remain there. We would be unable to view the picture as a whole. In fact, our focal point is a combination between points of attention and lines leading in and out. It is a road sign for our eyes, the direction which we follow visually. You must not imagine these lines literally as a strip. Emphases which follow each other in tone, texture, design, rhythm, colour and shape can lead our eye along a specific route. In general we do not locate our points of attention centrally but somewhat away from the centre of the picture surface.

Active – passive

A composition will gain in power and excitement if a strong contrast exists between active and passive areas. An active area is where something is happening, to where the eye is drawn, the area of focus. It is the spot where we step into the painting and where contact is made with the onlooker. Action can be shown by contrast and variation in colour, tone, texture and dynamics.

A passive area is one that exudes calmness. It is a part which does not attract our attention so much and which therefore emphasises the active area. Passive areas quietly give our eyes room to sound out more of the picture. It is important that you should always see the painting as a whole. There must therefore always be a definite contrast between active and passive areas. In addition, it is not intended that passive areas are 'empty'. They are only 'quiet' in relation to greater action elsewhere in the painting. Playing with surface division and surface division models can help us in this.

Surface division and types of composition	The division of our picture surface is the starting point for our composition. By means of the placement of the focal point and the main direction along which the shapes are arranged we can show a number of traditional surface divisions and types of composition, such as compositions in an 'S' or 'Z' shape, the circle, grid or cross, the diagonal, triangle and 'L' shape, the symmetrical composition and the composition in several layers.
New surface	New paths have also been sought in the abstract direction. It is a challenge to experiment, now and then, with alternative compositions. The models drawn below show where you can focus your action and where the quiet space or residual spaces can be. The active area can consist of the subject or theme and the passive area can be the background or environment. From the abstract point of view you have to intensify the realisation of active and passive areas by the use of contrast in colour, shape, size or texture.

The models vary from surface divisions which fill the picture with action and not much rest to little action and a lot of 'empty' space.

Examples of surface divisions.
The active area is shaded, the passive area is left blank.

Foreground and background	Foreground and background are one unit on our picture surface. This points to a frequent problem. We usually direct ourselves to our subject alone and do not realise that there is more. That is what a painting mirrors. Because our subject is reproduced on a flat surface this means that even the residual shape has a valuable function for the whole. We must consciously be aware of the fact that in a painting there is no dichotomy between foreground and background. A painting is a unit within which all the parts have a similar function. If we use closed shapes which do not touch the edges of our picture surface, this will emphasise the effect of foreground and background (closed composition). If we use open shapes, directed towards the edges of our picture, there will be a connection between foreground and background (open composition). If our shapes touch or exceed the edge of the picture, foreground and background are then equivalent and cannot be distinguished from each other or shown as separate. In this instance we have a composition which fills the picture.

Exercise 32 Active and passive

Theme/ emphasis	Playing with composition and surface division.
Picture elements	Shape, colour, tone, size, equilibrium, contrast, dynamics, repetition, rhythm, composition, focus, space.
Composition	A composition in which the emphasis is on the use of active and passive areas.
Materials	80 × 80cm (31½ × 31½in) painting canvas, acrylic paint, charcoal, brush.
Technique	Free-brush technique.
Work sequence	Design a composition in which there is a large, free passive area. Draw the composition on to the canvas with charcoal. Use only the three primary colours when working on it. Paint freely and let mixtures evolve on the canvas spontaneously. Remember to repeat colours in order to bring harmony to the work. Do no forget that there has to be a definite connection between the active and passive areas.
Tips	The calmer, and therefore quieter, the passive area, the stronger will be the attention paid to the rest of the painting. The contrast between active and passive ensures that there is more excitement in the work. To learn to work well with this important aspect requires some nerve. Consciously choose a large size, then there will be no need for delicate work and you will get used to free space in your work.
Variation exercises	1. Choose four different sizes on canvas or paper, and for each one design a different composition with a consciously selected passive area or areas. In each work use a different colour combination. 2. Make up a composition with a strong diagonal active area surrounded by free passive space.

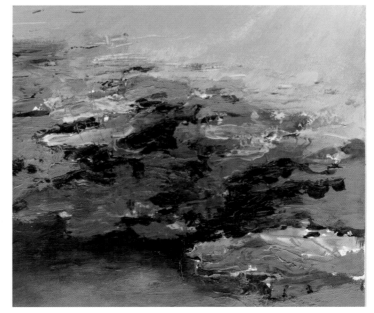

Study in acrylic on paper

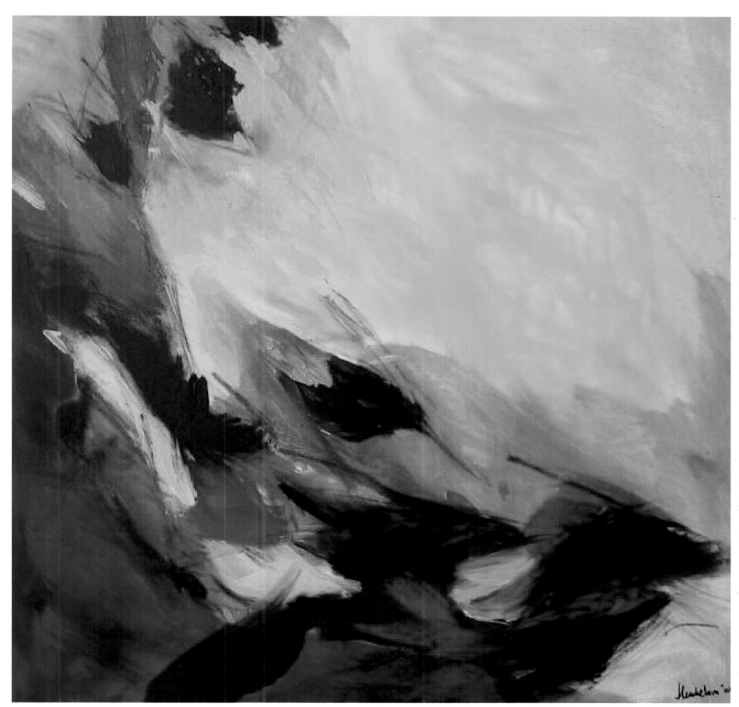

Acrylic on canvas 80 × 80cm (31½ × 31½in) (T. Heukelom)

Exercise 33 Foreground, background and space

Theme/ emphasis	Playing with open and closed composition.
Picture elements	Line, shape, colour, balance, depth, space, composition, free environment, focus, residual space.
Composition	Experience the difference between a composition which fills the picture, where there is no depth, and a composition with a free environment which allows the feeling of space to evolve. Illustration A shows an open composition which fills the picture and in which the lines and the shapes continue outside the picture surface. It appears as if the space continues outside the picture. Here we cannot see any foreground or background. Illustration B is a composition with closed shapes. The free residual space around them gives the concept of a background with regard to the closed shape. It gives us the suggestion of space and depth. The shape acts as a focal area and as the foreground.
Materials	Bristol card, oil pastel chalk, watercolour paint or acrylic paint, fine paint brush or brush.
Technique	Omitting and liquid wet-in-wet techniques.
Work sequence	Make up a line composition in oil pastel chalk with closed shapes and a free residual space, or open shapes which fill the picture and with no residual space. Then add liquid paint.
Tips	The effect of foreground and background is further intensified by colouring the shapes and leaving the environment white (C) or by giving it a totally different colour.
Variation exercises	1. Now make up a composition with open shapes and a free residual space around them. Only work in acrylic paint. Paint the residual space in a cool colour and the other central shapes in the composition in a warm colour. The effect of the colours will intensify the effect of depth. 2. Make up a composition which fills the picture with closed shapes. Give a cool colour to the shapes and apply a warm one around them. The effect of depth will be strongly reduced. Now only use oil pastel chalk.

A

C

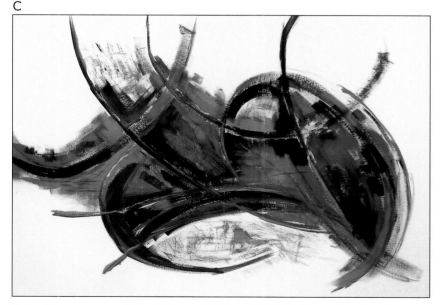

B

Acrylic on paper 50 × 70cm (19¾ × 27½in) (Y. v. Rooijen)

Exercise 34 Specific compositions

Theme/ emphasis	Playing with open and closed composition.
Picture elements	Line, colour, texture, tone, size, harmony, balance, composition.
Composition	This composition uses a surface division model in which the emphasis is on a horizontal focal area with a passive area above and below.
Materials	Paper, acrylic paint, brush, palette knife.
Technique	Direct a la prima and knife techniques.
Work sequence	Start with a thin underpainting without any composition sketch. Put a second layer on top. Now continue with acrylic paint and apply the paint directly with the knife, a la prima. Work wet-on-wet so that the colours can still mix. Work mainly in the centre and create a central horizontal focal area. The calm sections will then develop above and below.
Tips	In case the colours mix too much and there is inadequate contrast, it is useful to let the work dry and then to add some light contrasting touches.
Variation exercises	1. Do a number of spontaneous exercises in each of which a different composition is chosen. For these choose sketches from the composition alongside. 2. Finally design a number of new compositions yourself. Show them diagrammatically and keep them with your lesson material. Looking at work by other people may help you on your way.

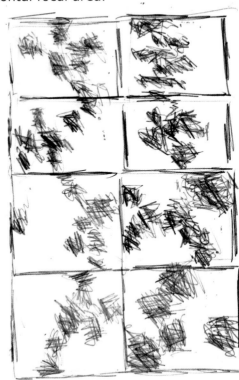

A

C

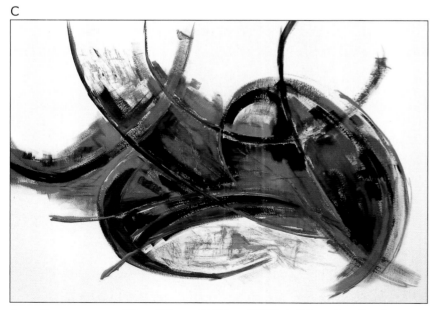

B

Acrylic on paper 50 × 70cm (19¾ × 27½in) (Y. v. Rooijen)

Exercise 34 Specific compositions

Theme/ emphasis	Playing with open and closed composition.
Picture elements	Line, colour, texture, tone, size, harmony, balance, composition.
Composition	This composition uses a surface division model in which the emphasis is on a horizontal focal area with a passive area above and below.
Materials	Paper, acrylic paint, brush, palette knife.
Technique	Direct a la prima and knife techniques.
Work sequence	Start with a thin underpainting without any composition sketch. Put a second layer on top. Now continue with acrylic paint and apply the paint directly with the knife, a la prima. Work wet-on-wet so that the colours can still mix. Work mainly in the centre and create a central horizontal focal area. The calm sections will then develop above and below.
Tips	In case the colours mix too much and there is inadequate contrast, it is useful to let the work dry and then to add some light contrasting touches.
Variation exercises	1. Do a number of spontaneous exercises in each of which a different composition is chosen. For these choose sketches from the composition alongside. 2. Finally design a number of new compositions yourself. Show them diagrammatically and keep them with your lesson material. Looking at work by other people may help you on your way.

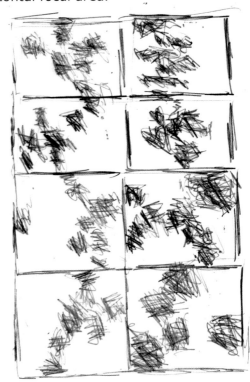

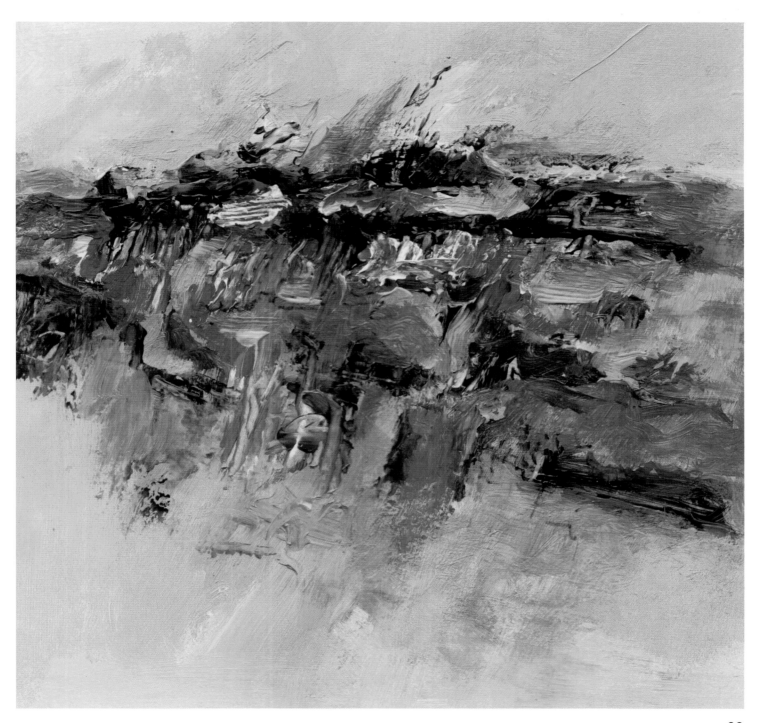

Exercise 35 Focal point on lines leading in and out

Theme/ emphasis

Playing with colour, shape and composition.

Picture elements

Colour, shape, texture, tone, emphasis, contrast, dynamics, harmony, equilibrium, composition.

Composition

A dynamic composition with a diagonal and horizontal focal area. The remaining picture surface is connected to the central section by line and colour emphasis. These emphases direct our eye to the centre and to the other sections of the picture surface; the emphases therefore act as lines which lead in and out.

Materials

80 × 100cm (31½ × 39¼in) painting canvas, acrylic paint, brush, palette knife.

Technique

Free painting and scraping techniques.

Work sequence

Decide where you want to have your focal area and where the connections to the other picture surface should be. Show this in a rough painting with a dark colour.
Let it dry and then continue with colour. Mix on the canvas and remember contrast in colour. Intensify the focal area by making scratches in the paint while it is still wet.

Tips

In order to create a focal point use the element of contrast.
Strong emphases will evolve by contrasts in shape, colour, tone and texture, which will demand our attention and create a focal point. The focal point will automatically be our active area and the other quiet sections will therefore be the passive areas. In this way a composition will have more excitement and power of attraction.

Variation exercises

1. Now repeat the exercise with a different composition and use a different material, for example a combination of felt pen and pastel chalk, or oil pastel chalk and gouache.
2. Try a composition with a strong vertical emphasis. Use colour and texture as connecting factors and emphases.

Acrylic on canvas 80 × 100cm (31½ × 39¼in)

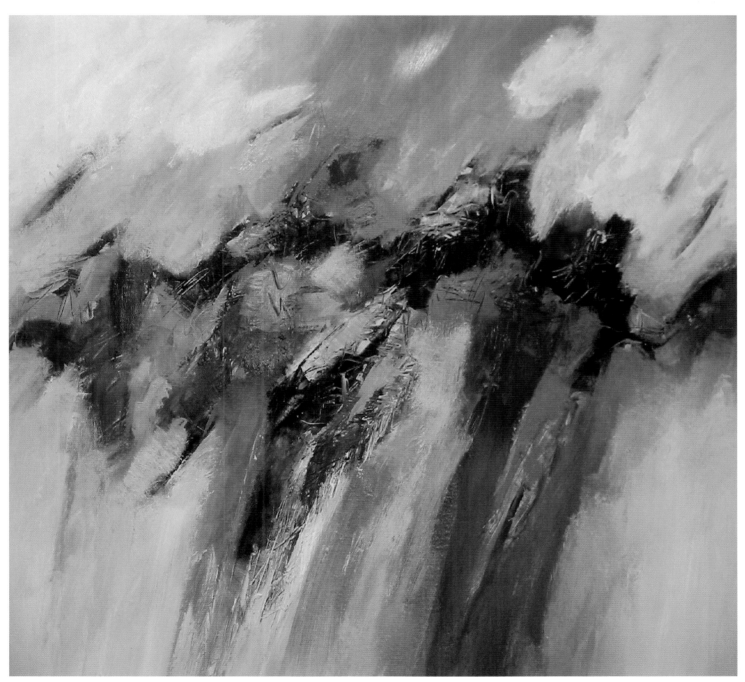

Acrylic on canvas 80 × 100cm (31½ × 39¼in)

Exercise 36 Types of composition

Theme/ emphasis	Playing with colour and composition shapes.
Picture elements	Shape, colour, tone, texture, size, contrast, harmony, balance, colour repetition.
Composition	A composition in the shape of a cross with the emphasis on a horizontal and vertical well-balanced focal area.
Materials	Painting canvas or paper, acrylic paint, brush, palette knife.
Technique	Direct painting technique built-up layer by layer, alternating with colour mixtures softly intermingling on the work.
Work sequence	Make a preliminary draft of a composition according to the cross-shaped sample. Roughly sketch the main lines on the canvas. Start by showing the various large colour fields, mix on paper and let the colours run into each other. Continue with the palette knife and apply some colour touches in the central focus area. Let it dry and apply another layer of colour touches until the result is satisfactory. Complete the work by covering the quiet areas in the four corners of the work once more with colours which are uniform and intermingle.
Tips	It is sometimes useful to make a sketch of the design where the different colours are also shown. A so-called colour draft can often be helpful during the painting process. Of course, this can always be deviated from during painting.
Variation exercises	In the art of painting we know a great number of types of composition: in addition to the shape of a cross, as in this exercise, we also know: Z-, S-, C-, X-, O-, L- and V-shaped compositions.

1. Now do an exercise in which another type of composition is used and choose smaller shapes and warmer colours for it.
2. In this exercise try to think of a variation on the types of composition or combine two types. This time choose large shapes and cool colours.

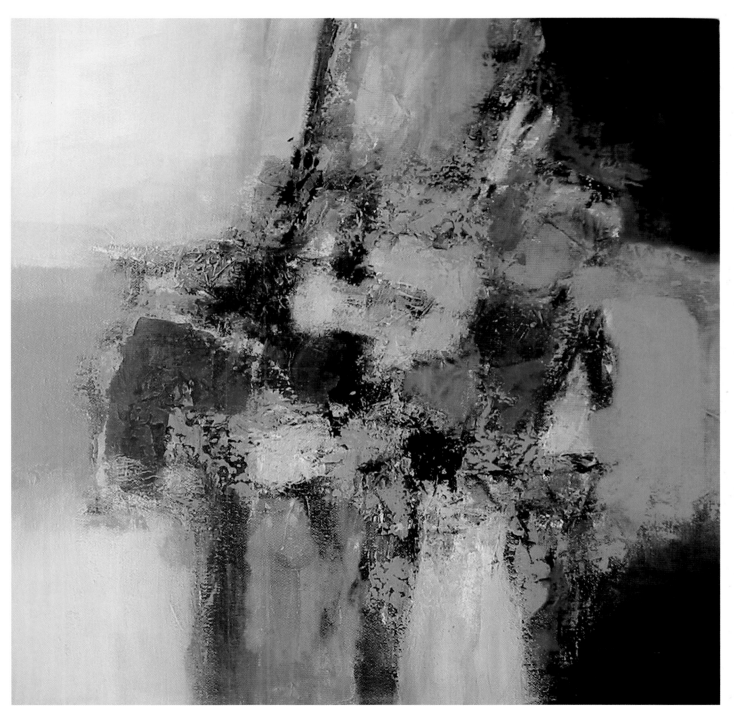

Acrylic on canvas 60 × 60cm (23½ × 23½in)

103

Exercise 37 Feeling for composition

Theme/ emphasis	Playing with colour and composition.
Picture elements	Line, colour, shape, equilibrium, contrast, dynamics, dominance, composition.
Composition	Free compositions, paying attention to composition.
Materials	Painting canvas or paper, acrylic paint, brush, palette knife.
Technique	Design technique. In order to develop the feeling for composition it is useful to dedicate a complete exercise to the subject. The rest is then merely of secondary importance so that we can concentrate fully on dividing up the surface.
Work sequence	Divide a large sheet of paper into six equal pieces. On each piece make up a different composition. Use only one colour plus black and white. Use pure and mixed colours in each composition. Let white dominate in two compositions, let black dominate in two others and let colour dominate in the last two. Next choose the best composition and rework it on a large size.
Tips	This type of practice can also be done in a small size, usually on a sheet of A4 in, for example, pencil or chalk. Divide up the surface with lines or make small colour sketches; these will strongly develop our feeling for colour and composition. In no time at all we have a large number of start-up sketches for a large painting.
Variation exercises	1. Take four sheets of paper and make up colour compositions in which a different passive area dominates in each composition. 2. Start again on four separate compositions in which each composition has a different dominant colour.

Exercise 38 Composition design technique

Theme/ emphasis	Playing with shape, surface division and composition.
Picture elements	Shape, colour, texture, contrast, composition, harmony, dynamics, contrast, balance.
Composition	A dynamic composition with diagonal as the main direction. Built up with free shapes in the focal area surrounded by passive areas. The shapes are placed as overlapping which develops depth and a coherence evolves between the separate shapes.
Materials	80 × 100cm (31½ × 39¼in) painting canvas, acrylic paint, brush, old newspaper.
Technique	Liquid drip and smooth covering paint techniques, preceded by design technique by means of torn-up newspaper.
Work sequence	Lay the canvas horizontally. Tear a few newspapers into pieces. The torn-up pieces are generally unpredictable and varied shapes and so are very good to use as free abstract shapes. Lay some pieces on the canvas and slide them around until you feel that you have created a good composition. Roughly draw round the shape with a pencil and remove the newspaper. Then the canvas can be put on the easel and be painted. Start with a watery dark underpainting and let it dry. Carry on with the drip technique in a lighter tone so that the drips ensure texture. Finish painting the work with quiet areas in smooth covering paint technique.

Tips

Due to the drip technique used here you can, of course, also adapt other texture techniques. I urge you to experiment as much as possible and to surprise yourself.

Design technique with torn-up newspaper

Variation exercises

1. Follow the same work sequence and now simply place the pieces of newspaper on the canvas. We are therefore going to follow the collage technique. The newspaper itself will also ensure a basic texture.
2. Using this technique now design a composition to fill the picture and paint it using a technique which you have chosen yourself.

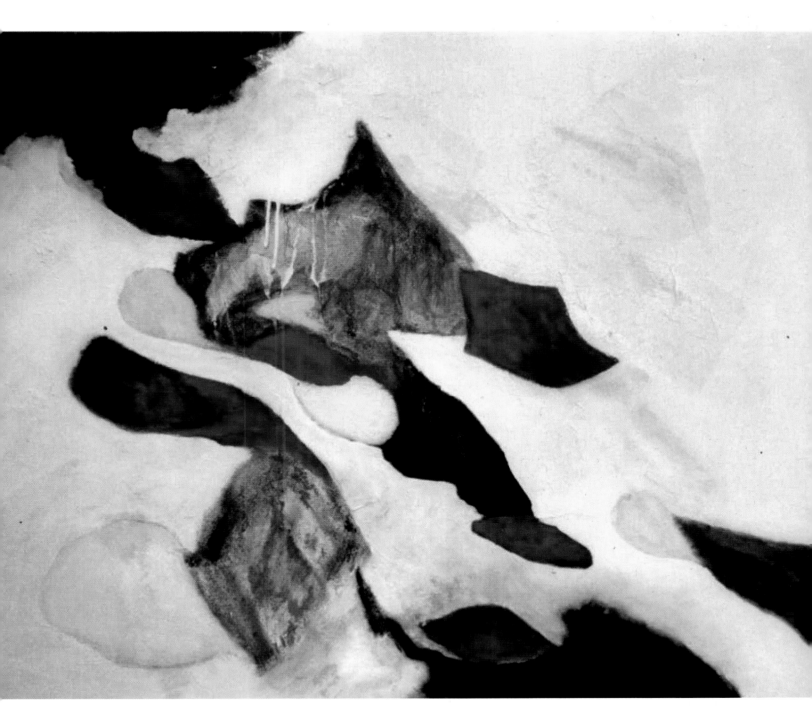

Acrylic on canvas 80 × 100cm (31½ × 39¼in) (R. v. d. Mheen)

11. Technique and material

Material and technique

Besides our imagery, material and technique are an important part of the artist's tools. Technique plays a dominant role particularly in abstract painting because in this we can express a lot of our creativity and artistry. For every abstract painter experimenting and investigating on a wide scale is also a source of inspiration, variation and experience which helps to produce original and exciting work. The more experience the better.

Knowledge and experience of the different drawing and painting materials are of crucial importance. What can we do with this material and what effect can it have on our work? An interesting question and an exciting source of discovery which really ought to be our starting point. To find out about the features of the different materials I would refer you to the specialist literature which exists on mediums such as watercolour paint, tempera, oil paint, pastel, chalk, etc. Here we are concentrating in particular on painting with acrylic paint because we can use it to carry out all of the techniques.

Acrylic paint

Acrylic paint is a modern material which is totally suited to this age. Strong in colour, it can be quickly processed, it is durable and can be applied directly to almost any background and can be combined with other materials in a way which is almost indestructible. After drying, acrylic paint is waterproof and cannot be dissolved, since it actually hardens as a plastic layer. Acrylic can be diluted with water and handled both in its liquid and in its pure thick form. The paint is therefore suitable for almost all painting techniques.

The adhesive strength of acrylic is such that the paint can easily act as a glue and can firmly hold both light and heavy materials. The quick, hard-drying effect makes it possible to paint directly over it and encourages working in layers. When the paint is still damp it forms a good base for the application of textures. Acrylic paint lends itself to other application techniques with which we can intensify our work artistically. In brief, a paint with a thousand and one possibilities.

Mixed techniques

As soon as different mediums and materials are combined we speak about mixed techniques. Adding fillers also comes under combination techniques, so there is still a lot to discover.

I am going to list a number of techniques so that you will have something to begin with. At first there are the usual techniques which we know from painting in watercolours and gouache, oil paint and tempera. I am also going to name some techniques which are used in this book and to which, for the sake of simplicity, I have given a specific name which refers to the procedure. Almost all the techniques named are used somewhere in the exercises in this book.

- Wet-on-wet technique
- Wash technique
- Glazing technique
- A la prima technique
- Direct technique
- Drip technique
- Spatter technique
- Blending technique
- Sgraffito technique
- Collage technique
- Knife technique
- Chalk technique
- Printing technique
- Stencil technique
- Line technique
- Contour technique
- Relief technique
- Brush technique
- Scratch technique
- Scrape technique
- Paint-out technique
- Repelling technique
- Sponge technique
- Roller technique
- Negative-paint technique
- Softening technique
- Hatching technique
- Dry-brush technique
- Blocking technique
- Spray technique
- Composition technique
- Design technique
- Mixing technique
- Structuring technique
- From dark to light technique

- From light to dark technique
- High-key technique
- Low-key technique
- Complementary technique
- Analogous technique
- Monochrome technique
- Covering technique
- Transparent technique
- Integration technique
- Mixed technique
- Line-pouring technique
- Line-stamp technique
- Rough-brush technique
- Suction technique
- Stamping technique

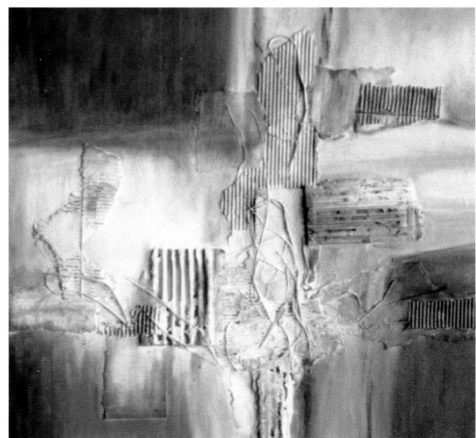

*Collage technique on canvas 40 × 40cm
(15¾ × 15¾in) (D. Nijenhuis)*

Exercise 39 Experimenting with liquid paint

Theme/ emphasis	Playing with paint, water and technique.
Picture elements	Line, shape, colour, texture, tone, contrast, variation, dynamics, harmony.
Composition	The job of the technique is to intensify the active focal area.
Materials	Acrylic paint, brush, paper or canvas.
Technique	Pouring, blending and dripping techniques.
Work sequence	Thin the paint with water in a tumbler. Pour the paint over a base which is at a sloping angle and let the paint run across it. Let the paint dry and continue the process with another colour. Do this once more if desired. Finally, apply contrasting colours in a rather liquid paint to some places with the brush and let this drip over the underpainting. Decide where the drips can intensify the focal area. Paint out some sections to show calmness. Rework it with covering paint.
Tips	During pouring and painting allow chance to play a part. Do not cover the whole underpainting. The white sections passed over give more contrast and emphasis to the work.

Variation exercises

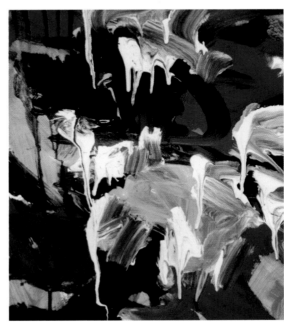

1. Apply an underpainting with free shapes in acrylic paint. Let it dry and continue with a watery dripping layer in order to give the painting surface a hint of the incidental and more texture as the focal area.
2. Start the next exercise with the drip technique and then, when dry, paint the work with the glazing technique.

Exercise 40 Experimenting with collage technique

Theme/ emphasis	Playing with texture and material.
Picture elements	Line, shape, colour, texture, tone, size, composition, harmony, contrast, rhythm.
Composition	A composition with the emphasis on equilibrium between the horizontal, vertical and diagonal directions.
Materials	30 × 30cm (11¾ × 11¾in) MDF panel, corrugated cardboard, gesso, acrylic paint, brush.
Technique	Collage technique. The material which is to be stuck on consists of pieces of cut-up corrugated cardboard. They are stuck to the panel with gesso. An acrylic medium or play glue can also be used.
Work sequence	Prepare the MDF panel by sanding it and painting it with white gesso in some places. Cut or tear rectangular shapes from the corrugated cardboard and use them to build up a well-balanced distribution. The pieces of cardboard form the picture elements shape, line, texture, rhythm and variation. The small lines of the corrugation also give direction to the composition. Place the pieces on the underpainting base and let the work dry. Rework the whole thing with colour and intensify the focal area by colour contrast. Remember to make use of the corrugations by painting the raised parts and by not touching the lower parts. The line and rhythm effect of the corrugation is then intensified, along with the focal area.
Tips	Instead of gesso you can also use acrylic wall paint to prepare the MDF panel. If you want a coloured underpainting you can also buy coloured gesso, or mix the wall paint with colour.
Variation exercises	1. Now do an exercise in which you use smooth cardboard along with corrugated cardboard – giving some variety to the texture. 2. In the next exercise continue to experiment with the cardboard. Cut specific shapes, tear pieces off from the upper layer of the corrugated cardboard and in some places scrape the corrugations away. Put them on the panel and paint them. This will give different textures to your collage material.

Exercise 41 Practising with a combination technique

Theme/ emphasis	Playing with collage, texture and mixed techniques.
Picture elements	Line, shape, colour, texture, tone, contrast, composition, variation, harmony.
Composition	A composition with central open shapes in line and texture.
Materials	Acrylic paper, old newspapers, sand, acrylic paint, Indian ink, brush, fine paint brush.
Technique	Collage, texture technique with sand, mixed technique with paint and ink, and glazing.
Work sequence	Place torn-up pieces of newspaper on the paper and let them dry. Continue with some colour touches with acrylic paint and scatter sand on to the paint while it is still wet. Then continue with thin transparent acrylic paint and glaze the whole thing. Add some line emphasis with a fine paint brush and Indian ink. When it is ready both the texture of the newspaper print and the texture of the sand will be visible. This will intensify and magnify the active focal area. Finally, rework it with covering paint.
Tips	If you use newspaper as an underlying texture remember that you only use the sections in black text and discard that text which is too large or paint out any photographs with white paint before continuing. Otherwise, these will command too much attention, unless the text itself is intended to be an essential part of your painting.
Variation exercises	1. In this exercise we can also easily change the work sequence. So now begin to do a drawing over the newspaper which has been stuck on first in ink and then with acrylic paint. 2. Also, try the possibility of newspaper, ink and watercolour paint.

Underpainting with newspaper

Newspaper plus ink drawing

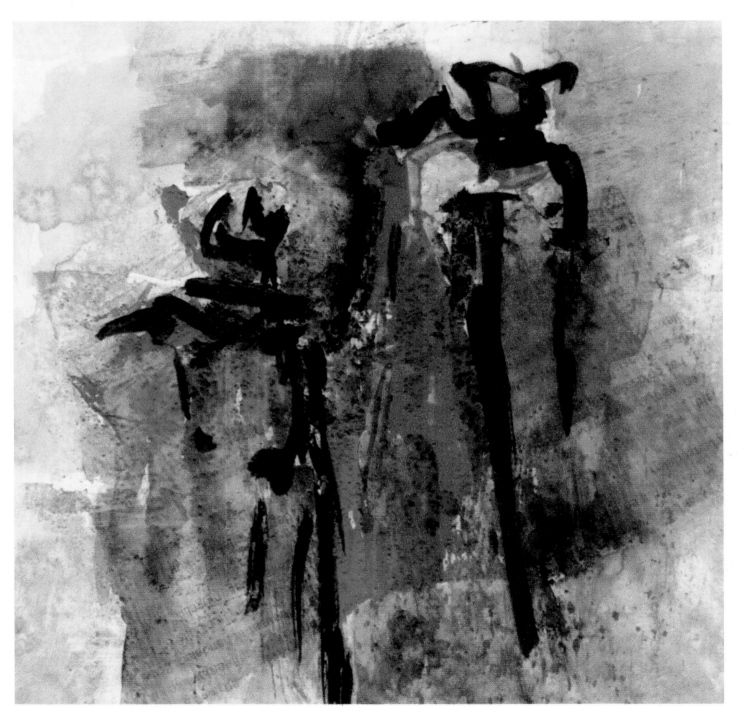

Mixed technique on paper 30 × 30cm (11¾ × 11¾in)

Exercise 42 Negative painting

Theme/ emphasis	Playing with positive and negative shapes.
Picture elements	Line, shape, colour, tone, texture, contrast, rhythm, design, dynamics, harmony, equilibrium, depth, overlapping.
Composition	A composition which fills the picture without any passive areas.
Materials	Acrylic paper, acrylic paint, pencil, brush, sponge.
Technique	Omission technique without aids. This means that you consciously omit sections and so do not paint them. Then you use a layering construction technique and the sponge technique.
Work sequence	Start with a very light underpainting. Draw a play of lines directly on to the work making a tangle of lines and forks which fills the picture. Then paint all around the lines in a medium-light tone. The omitted sections will remain visible as small stripes or bars (A). Let it dry and again draw lines all over the coloured section, which will actually lie behind the first light lines. Now paint the remaining shapes in a darker tone. The sections now omitted will be visible as a rather darker play of lines. Take care that in the second layer you also leave out the omission of the first round (B). Now repeat the process with a third, darker, tone. Finally your work will allow a rhythm of lines or forks to be seen in three different tones. Depth evolves in the work by overlapping and by placing the shapes on top of each other. In the last phase dab a contrasting colour over the painting with a sponge.
Tips	If you draw your lines double it will be easier to paint an open shape. Also paint over the pencil lines, we would rather not see these anymore.
Variation exercises	1. Repeat the exercise with another type of shape and now work from dark to light. Then begin with a dark underpainting and finish with the lightest tone (C, D, E). 2. In your next exercise do not choose monochrome colours but at each stage pick another colour. How will your work look with, for example, a sequence of yellow, red and blue?

A

B

C

D

E

Exercise 43 Working with fillers

Theme/ emphasis	Playing with colour, texture and filler.
Picture elements	Colour, texture, tone, lack of shape, dynamics, unity, harmony, repetition, depth by layering.
Composition	No special composition. The touches of colour and texture together will ensure that there is some division as well as an active focal area surrounded by calmness.
Materials	Painting canvas or acrylic paper, brush, palette knife, acrylic paint, marble powder, sand, old cloth.
Technique	Knife, layering construction, scrape and scratch techniques.
Work sequence	Begin with a smooth underpainting. Then with a palette knife apply some touches to the underpainting with pure paint. If required, thicken the paint by mixing it with marble powder. Scrape and scratch the paint with a palette knife while it is still wet; this will give it more texture, both tactile and visual. Repeat painting with the knife several times with different colours on each occasion. Finally add contrasting emphases. With a cloth wipe some parts smooth and level in order to create calm and passive sections by partly wiping away the texture. The texture and colour distribution will create the focal area in the work.
Tips	True layered painting takes a long time. If necessary, let the colour effects dry in order to keep the colour used clear. Take your time; the more layers there are the more interesting the surface will be and so ten layers are better than five.
Variation exercises	

1. Now begin with an underpainting and arbitrarily scatter sand over it. Let it dry and work on it by polishing it all over lightly with dry paint. By omitting some sections the underpainting will be visible (B, see blue parts). This intensifies the layering and depth in the work.
2. Now start with an underpainting which is totally thickened with marble powder. Rework the surface with a knife in order to give it structure.
 Then paint the whole thing with thin, watery layers of colour.

B *Acrylic on paper 50 × 70cm (19¾ × 27½in) (A. Stuivenberg)*

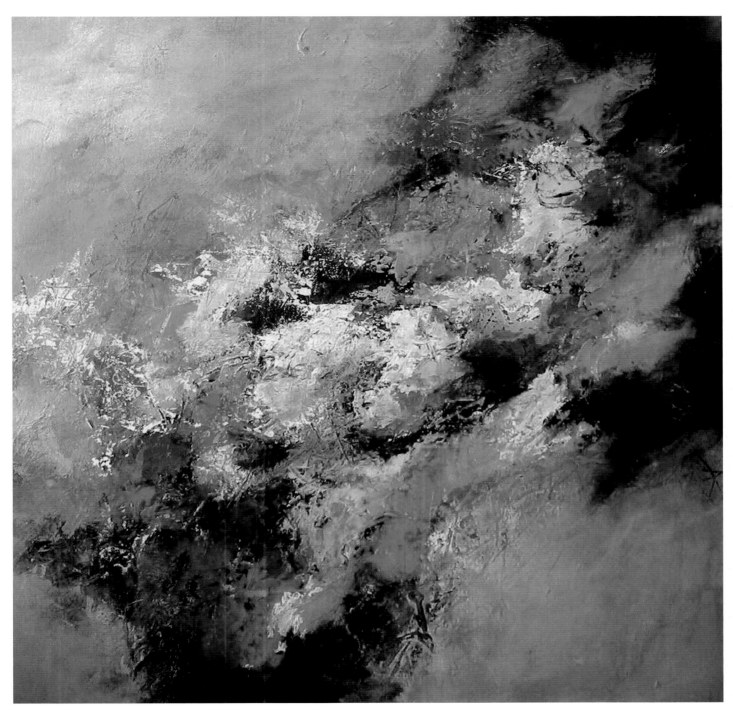

Mixed technique on canvas 80 × 80cm (31½ × 31½in)

Exercise 44 The palette knife as a painting tool

Theme/ emphasis
Playing with line, colour and the painting knife.

Picture elements
Line, shape, colour, texture, tone, contrast, dynamics, rhythm, harmony, unity.

Composition
During painting create a free composition which fills the picture where the texture and colour emphases act as a focus with space beside them for some uniform sections.

Materials
Square painting canvases, roller, palette knife, acrylic paint.

Technique
Direct a la prima technique applied with a palette knife as a tool.
As you can draw different strokes and lines with a brush, you can also do so with a palette knife. The more you experiment with this the more you will discover the possibilities of the tool. Use the knife both flat and angled. Rework large splashes with the long side of the knife. Use the tip for minor emphases and for scratching into wet paint.

Work sequence
Work on two or three painting canvases at once. Give all the canvases an underpainting in a different colour and use either a palette knife, a brush or a roller.
Then with the knife make up a free-line composition over the underpainting colour. Draw long strokes across the canvas with the knife. Let it dry.
Then continue with other colours and do some minor paint touches. Use the knife both flat and at a slight angle and both the tip and the side to vary your technique. Apply the paint and then scrape away any excess paint.

Tips
Instead of a palette knife you can also try to paint with a stopping knife, a spatula or a stiff piece of cardboard. These will all give more or less the same effect.

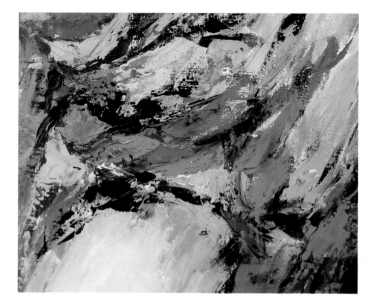

Variation exercises
1. Take a couple of small sheets of paper and experiment with the palette knife on each sheet with a different main colour combined with only white and black.
2. Rework a large sheet of paper with the knife and paint in different colours.
 Let it dry and glaze the whole thing in one colour.

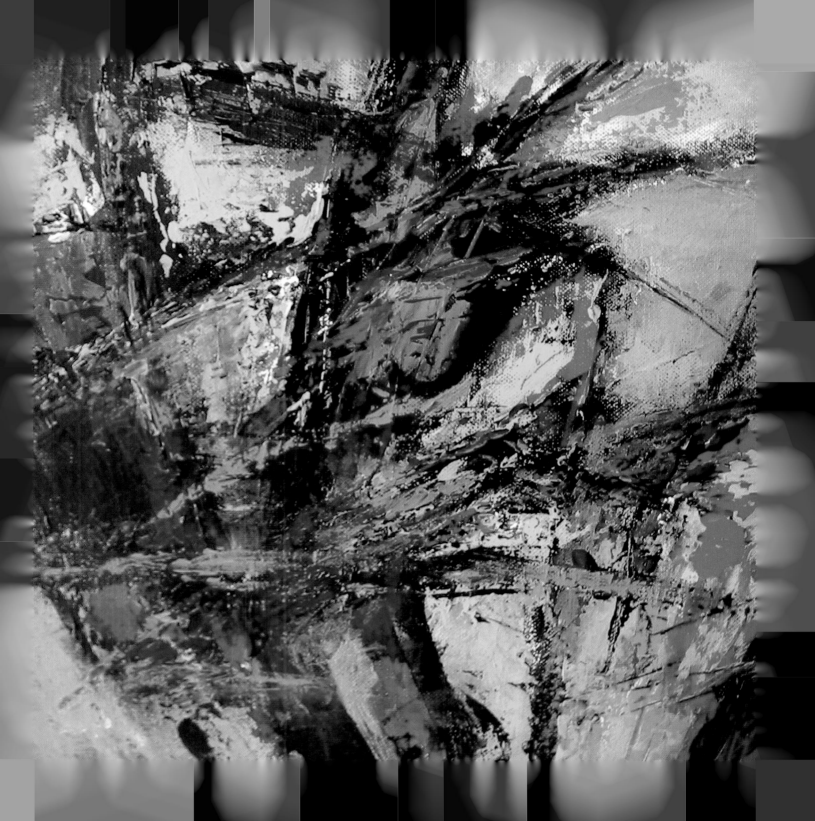

Exercise 45 Nature as collage material

Theme/ emphasis	Playing with shape, colour and texture.
Picture elements	Shape, variation, colour, texture, contrast, rhythm, harmony, unity.
Composition	Make a free composition with natural materials.
Materials	Acrylic paper or canvas, gesso or acrylic medium, acrylic paint, brush, dried leaves.
Technique	Collage and integration techniques.
Work sequence	Compose a well-balanced composition with the leaves and place the leaves on the underpainting using gesso or an acrylic medium. Select a number of unnatural colours and paint the whole of it. In doing this the leaves are painted along with the rest of it so that they form part of the different colour fields and are therefore integrated into the whole work.
Tips	For the variation always use different types and therefore shapes of leaf. Now and again also use leaves which have been torn up. These make your work less predictable and more interesting in shape.
Variation exercises	1. Do an exercise with leaves in, for example, only white or in another colour. 2. Now do an exercise with leaves in which you consciously leave the colour of the leaves alone and adapt the colour of the environment to them. In this case glue your leaves on the surface with a transparent adhesive, such as acrylic medium.

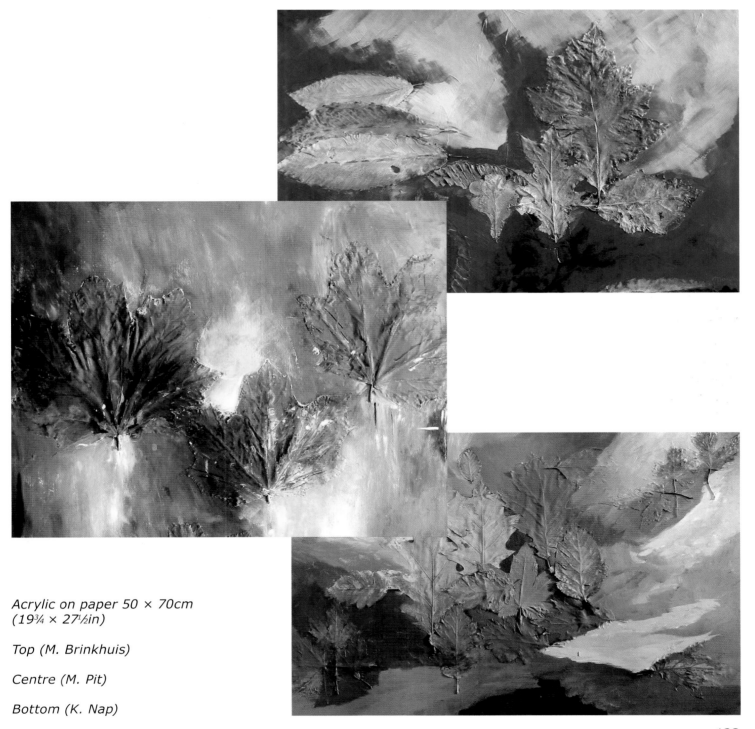

Acrylic on paper 50 × 70cm
(19¾ × 27½in)

Top (M. Brinkhuis)

Centre (M. Pit)

Bottom (K. Nap)

Exercise 46 Exploring with printing technique

Theme/ emphasis	Playing with line, shape, texture and printing technique.
Picture elements	Line, shape, texture, colour, contrast, composition, rhythm, dynamics, balance, variation.
Composition	No specific composition is made. The actions will probably result in a dynamic composition because the lines and shapes express action.
Materials	Stiff paper, a sheet of glass, acrylic paint, brush, pieces of cardboard or wood.
Technique	Monoprint technique. Here paint is applied to a sheet of glass. A drawing is made into this paint and then the paper is laid on the sheet. Press down on it and remove the paper. The paint is now transferred from the sheet to the paper. Each print is therefore unique. Before the next print more colour should always be applied and reworked so that the effect will always be different.
Work sequence	With two colours, paint a rough and expressive surface on to a sheet of glass. With a piece of cardboard or wood scrape away areas of the paint. Lay a sheet of paper on top of it and lightly wipe it over. Remove it and your print is ready. Try again to make a print with a second and third piece of paper, they should always contain less paint. Then use the print as the basis for a painting by going on to paint out sections with paint and a brush and adding emphases.
Tips	Remember that a thin layer of acrylic paint on a sheet of glass will dry very quickly, preventing you from doing any more to your work. Therefore work quickly and, after printing, wipe the sheet clean again immediately. In order to make monoprints you can also use printing ink instead of acrylic paint. If you do not have a sheet of glass you can also usually paint the layer to be printed on to a stiff piece of smooth paper or card.
Variation exercises	1. There are many ways of making a monoprint. Try the following as well: cover the sheet of glass with a thin layer of paint. Place a piece of thinner paper on to it and scrape arbitrary lines on to the paper with the back of the brush. The paper will take the paint up from the sheet of glass where you have been scraping. 2. Consult a book with printing techniques and experiment with the many other possibilities. You can consider your print as an end product, but you can also use it as an underpainting for a future study.

Exercise 47 From old to new

Theme/ emphasis

Playing with colour, shape, texture and composition.

Picture elements

Line, colour, shape, contrast, tone, texture, harmony, unity, active, passive, texture, dynamics.

Composition

A carefully designed composition, central or diagonal, filling the picture or with a free residual space around it, in order to intensify the active focal area and the passive residual space.

Materials

Painting canvas or stiff acrylic paper, an old work on paper, an acrylic medium such as an adhesive, paint, brush, palette knife.

Technique

Collage and integration techniques.
The latter requires some explanation. It is a technique geared to unusual elements, such as the cut-out shapes used here so that they no longer appear as 'loose' items to be shown but are accepted into the whole work. This is achieved by applying the same colour and thickness of paint to some of the pieces which have been stuck on as compared to the environment next to them.

Work sequence

From an old unwanted work cut out some abstract free shapes.
From these make up a composition and stick them on to the canvas or paper.
Then paint the whole thing until a unity is achieved and everything is integrated so that it is hardly noticeable that it is a collage. Choose colours which are already present in the pieces making up the collage, or simply use contrasting colours.

Tips

Choose a colourful work for the collage pieces. Instead of cut-up shapes you can, of course, use torn-up shapes.

Variation exercises

1. Make another new work from an old one, but now cut out figurative shapes. Play with these by cutting them up into pieces and sticking them on so that the shapes are interrupted and a more abstracting imagery is produced.
2. Try to build up a work using this collage technique in which the whole picture surface is covered by pieces from an old unwanted work. If necessary, use two different old works for the colour contrast.

Collage on canvas 50 × 50cm (19¾ × 19¾in) (E. Wateler)

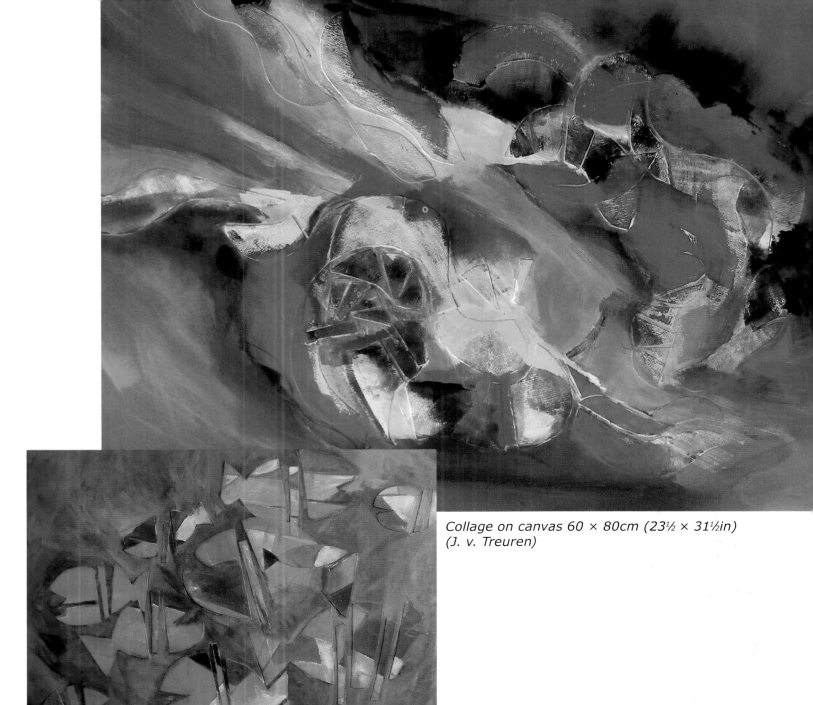

Collage on canvas 60 × 80cm (23½ × 31½in) (J. v. Treuren)

Collage on canvas 60 × 80cm (23½ × 31½in) (H. Haak)

Exercise 48 Working in water with salt or ink

Theme/ emphasis	Playing with line, colour, water and texture.
Picture elements	Line, shape, colour, harmony, tone, size, harmony, contrast, dynamics, variation.
Composition	A previously designed composition constructed with flowing lines which fills the picture and extends to the edges.
Materials	Watercolour paper (minimum 300gsm), watercolour paint, fine paint brush, wax candle, course grain sea salt, Indian ink.
Technique	Wet-on-wet flow, repelling and suction techniques. The fact that in wet paint salt absorbs the paint results in a lighter ring developing around the salt grain. This produces an interesting texture effect within the flow technique.
Work sequence	Design your composition and draw it on to the watercolour paper with a thin pencil line. Trace over the lines with a wax candle. Press down well with the candle so that a wax layer remains on the paper. This will repel the paint and so the liquid paint will remain inside the lines. Continue with watercolour paint and colour everything. Remember colour variation and contrast. In some places, scatter sea salt into the wet paint and let it dry. Finally wipe off the dried salt grains.
Tips	You can also produce the lines which were made with a wax candle by using white or coloured oil pastel chalk. Do not forget to remove as much of the salt as possible, or it will continue to attract fluid and bubbles or mould may form on your work.
Variation exercises	1. In the next exercise start by applying an underpainting which is completely coloured and scatter salt on to it arbitrarily. Let it dry a bit and draw the composition on to it in ink. Then go over it again and rework sections of it with coloured pencils. 2. Design a composition with clear shapes. Cover the paper with watery paint. Let it dry and draw in the forms with pen and ink. If the paint is too wet the drawing will spread. If the paint is too dry the line will become too hard. Try to find the middle path.

Watercolour and ink

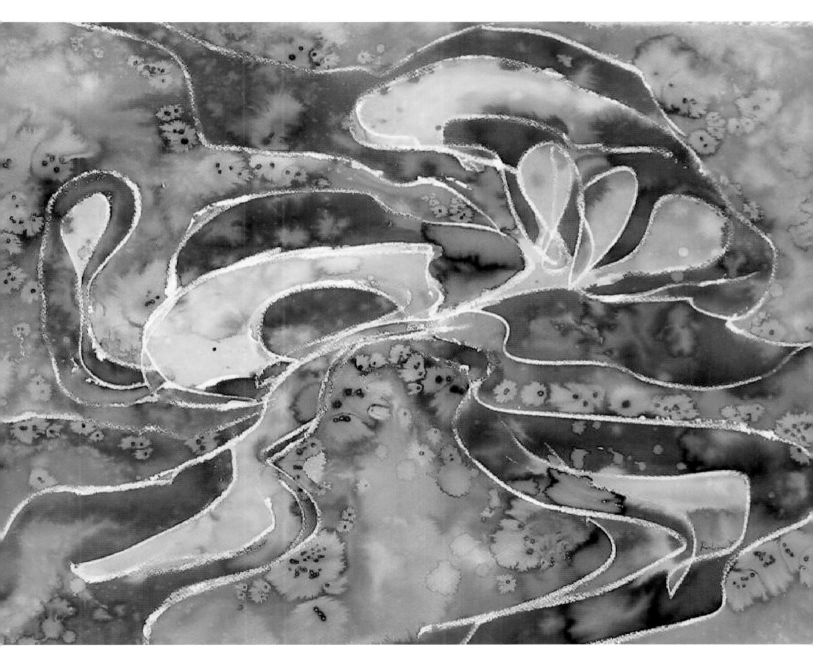

Mixed technique with watercolour and salt on paper 50 × 70cm (19¾ × 27½in)

Exercise 49 Paint-out technique

Theme/ emphasis	Playing with line, shape, colour and texture.
Picture elements	Line, shape, colour, tone, size, texture, dynamics, harmony, domination, variation, complementary contrast.
Composition	A dynamic composition with large 'loose' abstract shapes which fill the picture and extend outside the picture surface.
Materials	80 × 100cm (31½ × 39¼in) painting canvas, acrylic paint, sponge, large broad flat brushes.
Technique	Sponge and drip techniques; and an expressive covering a la prima technique as a paint-out technique. This means that underlying sections are covered with a thick layer.
Work sequence	Design a free composition with abstract shapes which are scattered loosely over the entire picture surface. Transfer the shapes to the canvas with a brush and paint. Then cover the whole picture surface, shapes and environment with a coloured layer by dabbing over it with a sponge dipped in paint. Scrape it while it is still wet with the back of the brush. Continue painting around the shapes with an opaque (covering) colour. In doing so keep the paint rather liquid and let it run over the shapes. Finally paint the remaining area in a complementary colour with thick paint and remove parts of the shapes. Use a large broad brush and leave the expressive brushstroke showing. Both the shapes and the rest will contribute to the whole texture.
Tips	Chance is an important factor in this work. A lot of experience is required in order to master this technique. If necessary, start again if you are not pleased with the result.

Variation exercises	1. Apply some free colour areas with your largest brush. Let it dry and pour paint over it and let it run. Let it dry again and, with white paint, paint out sections which you can do without. 2. Cover an entire canvas with stamped prints made with a sponge, perhaps combined with drips and splashes. Then paint out some sections so that the rest is left as a positive shape and a focal area.

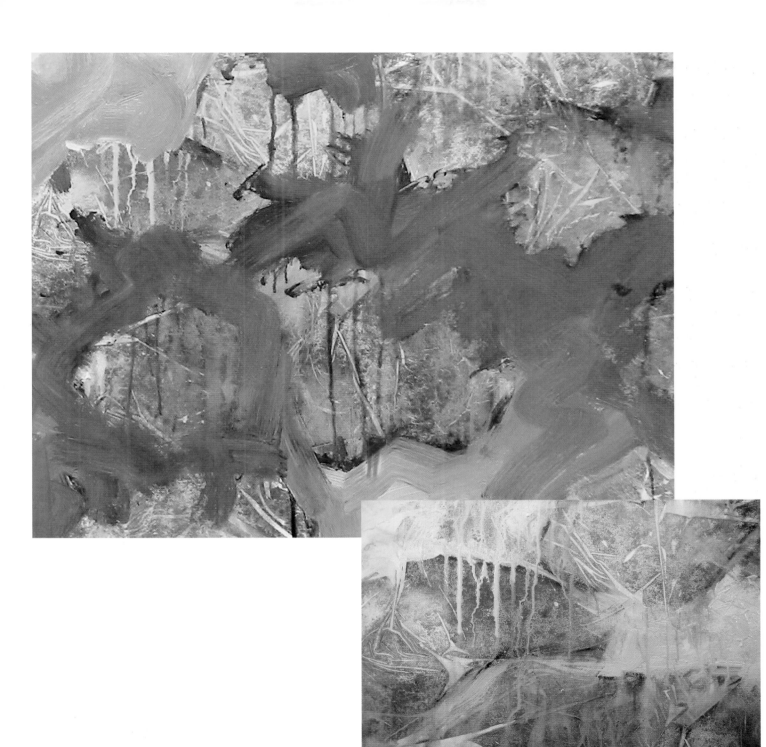

131

Exercise 50 Texture technique with print designs

Theme/ emphasis	Playing with texture and colour.
Picture elements	Shape, colour, texture, rhythm, design, dynamics, harmony, variation, unity.
Composition	The composition will be decided later and will evolve from the result of the print design.
Materials	Canvas or acrylic paper, acrylic paint, foil or soft plastic, brush.
Technique	Print technique with transparent foil. In this technique crumpled foil or plastic is pressed on to the wet paint and is removed after it has dried. A strongly textured design will then remain on the canvas. This creates an interesting underpainting on which to build up the painting.
Work sequence	Cover the canvas with liquid paint in two or more colours. Put the foil on top of it, press it down and push in any wrinkles. Leave it lying flat to dry. Remove the foil and go on to paint the work according to your own ideas. Decide what the composition will be according to the effects which develop.
Tips	If the first result is not inspirational enough repeat the procedure. Use transparent plastic as the underpainting will be seen through it more easily. Take care not to have too much texture. The following applies to any texture: you can have too much of a good thing.

Variation exercises

1. Start the work with an underpainting in one colour. Let it dry and pour a complementary colour over it. Press foil on to it, let it dry and paint it.
2. Now make a complete painting the composition of which has been decided in advance.
 In this case add the texture with the foil print to the work as the last stage. Remember how you were taught to work with discretion.

Texture technique. Detail

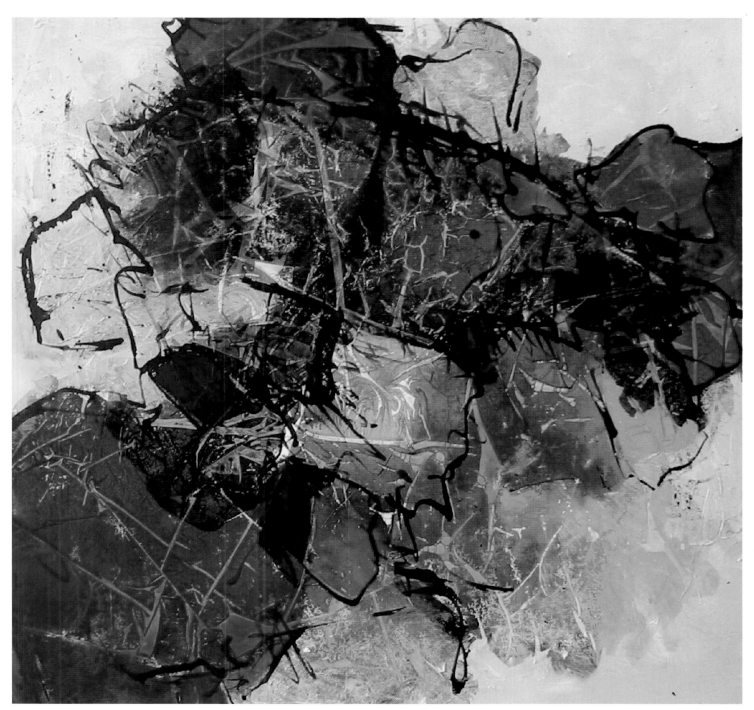

Acrylic on canvas 80 × 80cm (31½ × 31½in)

Exercise 51 The sgraffito technique

Theme/ emphasis	Playing with colour, texture and rhythm.
Picture elements	Line, colour, shape, texture, tone, contrast, harmony, unity, rhythm, dynamics, design.
Composition	The composition consists of a central, diagonal active area in addition to the remaining large passive areas.
Materials	Painting canvas or stiff acrylic paper, acrylic paint, brush, palette knife.
Technique	Sgraffito and colour blending techniques. Here the colours are brushed into each other while they are still wet. The sgraffito technique is developed by scraping into the thick wet coat of paint with a sharp instrument.
Work sequence	Design a composition with active and passive areas. Start with a completely black underpainting. Then apply a thick layer of colour into the active area of the composition with the painting knife. With the back of the brush scrape designs and rhythms into the paint while it is still wet. Now cover the remaining passive areas with white paint and try to bring these into contact with the coloured active area by brushing the colours into each other. The connection between the active and the passive area evolves by the colour transition and the sgraffito design.
Tips	Always use the sgraffito technique in combination with a strongly contrasting underpainting, as the design will then be most strongly visible. Also, always combine the technique with quiet, passive, smoothly painted areas, or else the work will be too lively.
Variation exercises	1. Now repeat the exercise with a light underpainting and a dark finishing colour. 2. Now use a composition which was constructed in advance and only process some parts with sgraffito in order to intensify the focal area. Finally, you can also choose other colours.

Sgraffito technique. Detail (C. Ruyters)

Right-hand page
Acrylic on paper 50 × 70cm
(19¾ × 27½in)
(D. Nijenhuis)

12. Theme and project

Abstract painting subjects

Even when we are painting abstractly we always have to consider the question: 'What am I painting?' In other words, what is my subject, my theme? For the abstract artist the theme is, in principle, not figurative and the subject can then easily be linked to the abstract values of the painting. The theme can therefore be a play with lines, a play with shape and colour, a play with texture and composition or simply experimentation, texture technique, etc. Until now all the studies in this book have been presented to you in the same manner.

Reality

Besides the abstract themes we can of course also use reality within the confines of abstract art. The aim is to process reality in a way which is entirely our own, to transform and restructure it into something new, something individual and unique. This is when the rules of abstraction become useful (Chapter 4 What is abstract?).

'To see' abstractly

If we first train ourselves to learn to 'see' abstractly there are a great number of abstract themes in reality, in our environment and in everything that we come across, in which we as artists can engage. So learn to see reality differently and to use it in your own way and a new world of possibilities will open up before you. Your creativity will then not be limited by the dictates of reality. For example, a cloud can be purple and square etc.

Projects

As soon as a theme grips us we can of course get a lot more out of it than simply one piece of work. Within a theme each study can be differentiated by for example the use of other material, another technique or another composition. A simple subject such as a coffee pot should be able to supply a whole string of works. Within our study we interpret that by the term project. In this way a theme offers us several opportunities. The deeper you go into a theme the more the possibilities expand, so we are no longer without a subject.

Design strategy

In general, projects demand more from us. We have to immerse ourselves in the theme and make the necessary preparations. The preliminary thought process needs more time. The collecting of documentation is also included in the preparations for a specific project. As soon as our ideas start to grow we are at the design stage and we need to have a design strategy. During this design technique we go through a number of artistic facets which have to be considered before we start.

The design strategy includes the following steps and moments of choice:
1. the subject
2. the material
3. the picture surface
4. surface division and composition
5. the picture elements
6. the colour plan
7. the design.

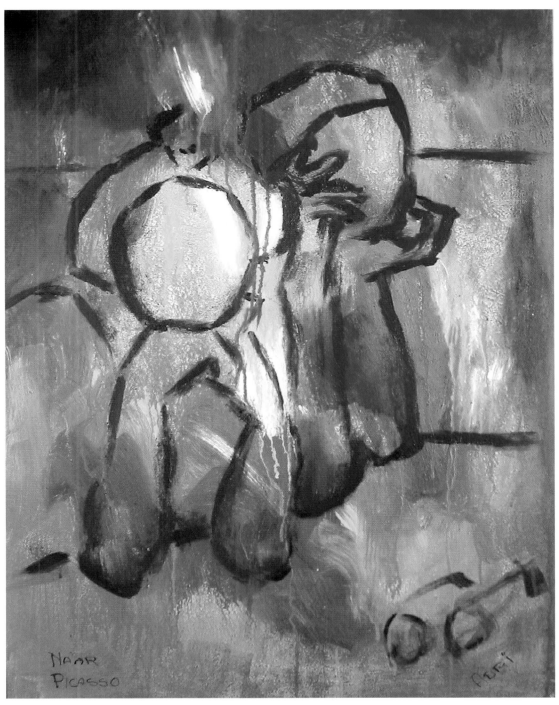

Execution of study No. 55. Acrylic on paper 50 × 70cm (19¾ × 27½in) (A. Stuivenberg)

Exercise 52 Abstracting from a landscape

Theme/ emphasis	The theme of constructing a landscape.
Picture elements	Line, shape, colour, rhythm, texture, tone, contrast, composition, equilibrium, harmony, size, dynamics.
Composition	A simple composition with a strong horizontal emphasis with cloud-like shapes as the focal area. Every composition in which a horizontal path is visible is also quickly associated with a landscape. This is all the more intensified by a flat, rectangular picture surface.
Materials	60 × 80cm (23½ × 31½in) painting canvas, acrylic paint, brush, roller.
Technique	Direct a la prima painting technique and roller technique.
Work sequence	Design a simple landscape on a sketch pad. Choose a range of monochrome colours and deviate from the natural colours; in this way the picture will become a bit more abstract. Apply the composition to the canvas with simple paint strokes. Paint the work with a knife and brush (A).

Tips

If you paint with straight vertical strokes the two-dimensional flat surface will be emphasised. Abstracting is intensified by avoiding spatial curves (which would suggest depth).
The more you leave out the effects of perspective the more abstract your landscape will become.

Variation exercises

1. In order to ensure your landscape is completely abstract turn your landscape composition through 90° and then paint it.
 Choose unnatural colours. This will also ensure your work is abstract.
2. Now use only a roller as a tool on your vertically turned landscape (B).

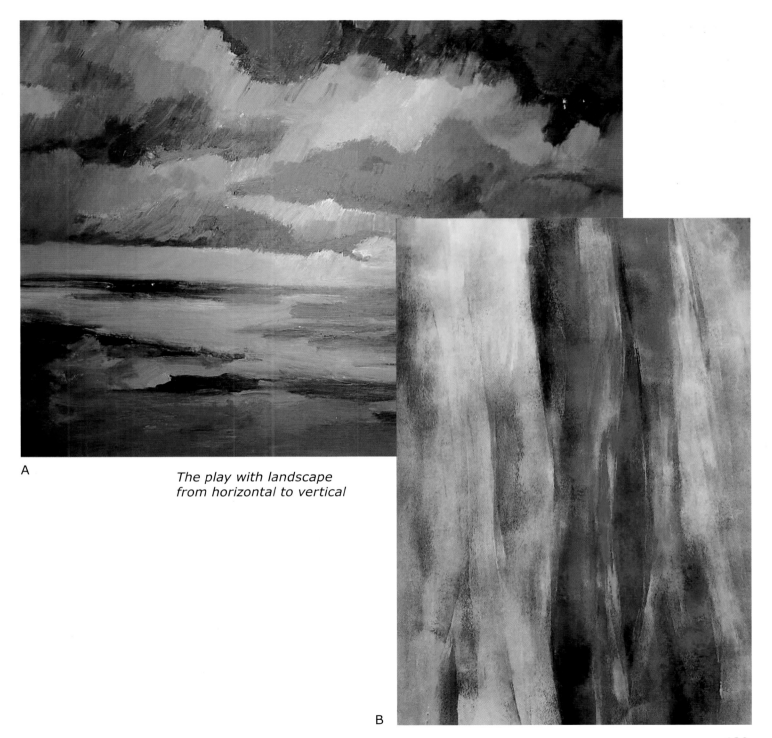

*The play with landscape
from horizontal to vertical*

A

B

Exercise 53 Find your own variation

Theme/ emphasis	Somebody else's work as a source of inspiration.
Picture elements	Line, shape, colour, texture, tone, harmony, dominance, gradation.
Composition	The composition and the shape are transferred from the example. Here a work by Matisse has been chosen as the source of inspiration. The shape can be applied with more residual space (A) or as filling the picture with no residual space (B).
Materials	60 × 80cm (23½ × 31½in) painting canvas or acrylic paper, acrylic paint, sand, brush, palette knife, watercolour paint, fine paint brush, watercolour paper for the second execution of the theme.
Technique	Knife, brush and wet-on-wet flow techniques.
Work sequence	Begin by applying an underpainting. Choose a similar range of colours with a strong dominant colour for the whole work. Mix the paint with sand and apply it with the palette knife to the shape and the sections of the environment. Paint the whole thing with a brush, giving more or less the same colour to the shape and environment (A).
Tips	If the same colour and tone are used for the subject and the environment the work will seem more abstract because there is no effect of depth coming from the environment. The shape is therefore subsumed into the environment and is much less strongly present than in the example, where there is maximum contrast (C).
Variation exercises	1. It is obvious that in the next exercise you should use the contrast and perhaps paint the environment with a complementary colour. 2. The subject is also suitable to experiment with in other materials and techniques. Therefore, choose to execute it in watercolour. Start with a wet-on-wet base layer splashed with paint, let it dry and then cover the negative space with a second colour. You then paint around the shape of the figure (B).

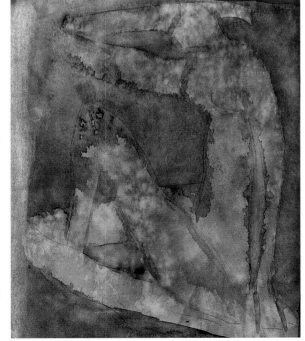

B *Watercolour on paper*

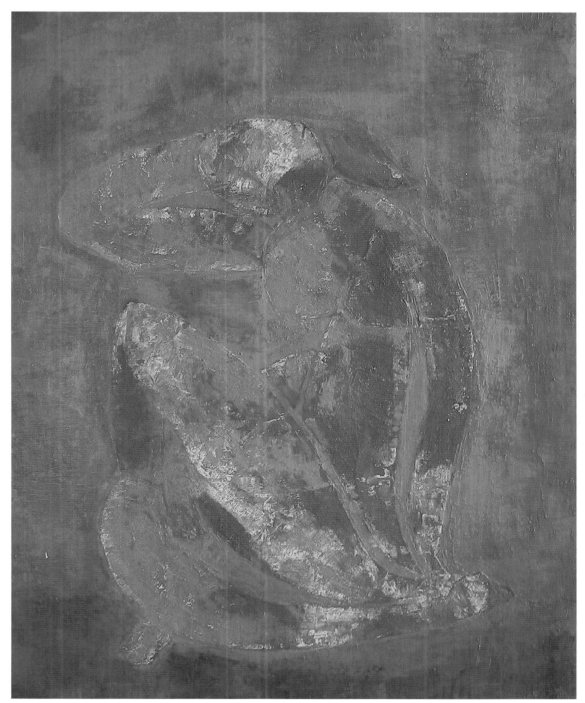

C

A *Acrylic with sand on canvas 60 × 70cm (23½ × 27½in) (H. Haak)*

Exercise 54 Looking for rhythm as a theme

Theme/ emphasis	Inspired by the rhythms of nature.
Picture elements	Line, rhythm, tone, contrast, colour, shape, texture, size, gradation, composition, harmony.
Composition	A rhythmic composition surrounded by a lot of free residual space with vertical emphasis in a horizontal path bringing balance to the composition.
Materials	Painting canvas or paper, acrylic paint, brush, palette knife.
Technique	Knife, brush and structure techniques.
Work sequence	Let yourself be inspired by the rhythm of, for example, reeds, trees, branches, etc. Without any preliminary composition start to put rhythmic stripes on to the canvas with the palette knife and pure paint. The colours will mix during the work. Combine the loose rhythmic stripes by giving colour to the residual space. Scrape in a horizontal direction into the paint while it is still wet in order to intensify equilibrium and focal area.
Tips	Here we use a visual vertical rhythm from nature. There are, of course, also horizontal rhythms to be found in nature, for example, in the ripples on water. Vertical and horizontal rhythms go hand in hand – we are always looking for balance in our composition. A vertical dominance therefore requires a horizontal complement and vice versa.
Variation exercises	1. Using a pencil, design a rhythmic well-balanced composition, inspired by, for example, a photograph of a bush or reed, etc. Apply the composition directly on to the base with oil pastel. Choose unnatural colours in order to move away from the reality. Use the chalk thickly and draw it over each colour so that they mix. 2. Now try a similar rhythmic emphasis on a vertical narrow picture surface and repeat it on a horizontal narrow picture surface.

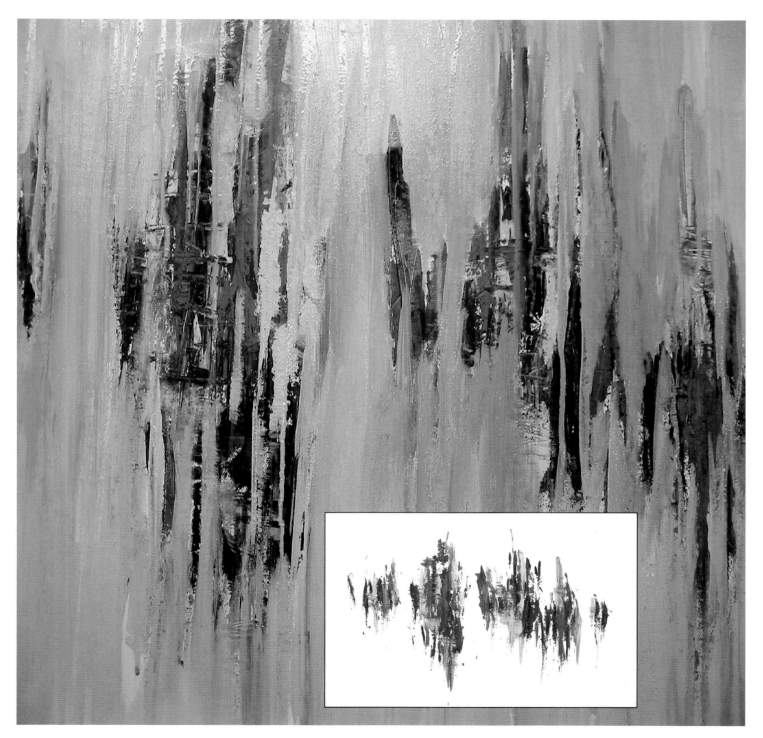

143

Exercise 55 Working on a style variation

Theme/emphasis	Inspired by your own work.
Picture elements	Line, shape, colour, tone, texture, harmony, composition, contour, unity, variation.
Composition	A central composition which almost fills the picture surface and in which the shape is only applied in contour.
Materials	Acrylic paper, acrylic paint, brush, artist's knife.
Technique	Expressive brush and knife techniques.
Work sequence	Find an exercise which you did earlier, for example a realistic painting of a group of people. The work needs to be in the figurative styl.
	From the work take out the main shapes and draw them in a notebook, but only in contours. You can use the notebook to try out your new composition.
	Start with applying a polychrome and expressive surface to the paper, taking no notice of the shapes which are later going to be placed on to it.
	Then with a brush paint a rough line sketch of the shapes over the whole thing and rework it to your satisfaction.
	The polychrome underpainting, which does not have any direct relationship with the shape and which is only visible in contour work, will give the work a totally different character than a work which has been painted according to reality.
Tips	For this choose a realistic work which was done entirely by yourself.
	By carrying out one of your own works in a different style you will obtain a lot of experience in intensifying your own style and the originality of your work.
Variation exercises	1. Take the same original work once more and rework it in another picture size and using another material.
	2. Then choose two other works by yourself and begin to work on them. Do not use natural colours and experiment with other techniques. Rework both of these exercises into a new entity.

Acrylic on paper 50 × 70cm (19¾ × 27½in) (D. Mol)

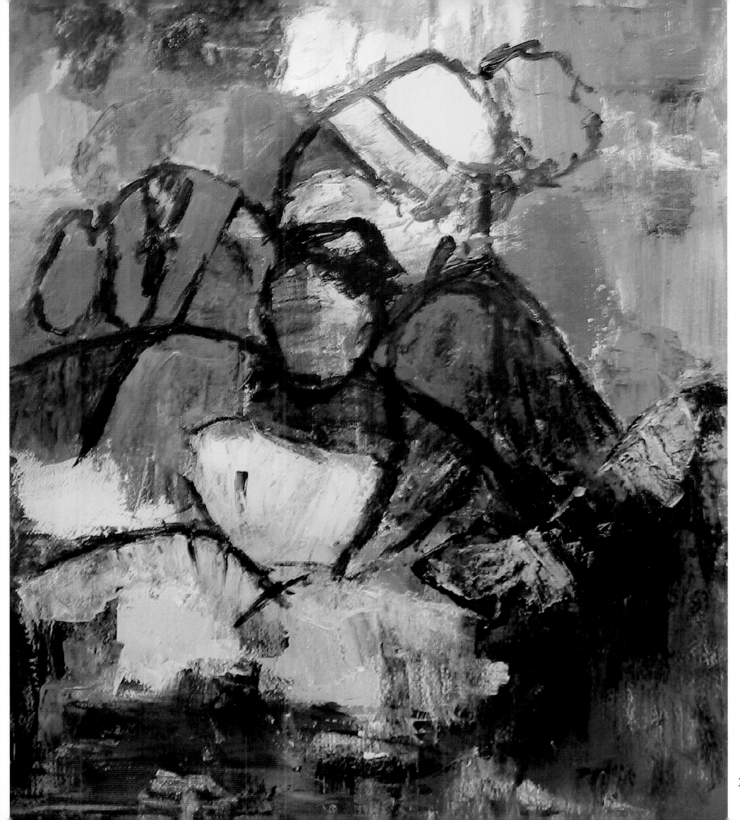

145

Exercise 56 Text processing

Theme/ emphasis	A poem as imagery.
Picture elements	Line, colour, texture, tone, contrast, unity, harmony, gradation.
Composition	A composition in which the text is distributed across the whole surface; the colour fields add a diagonal emphasis to the whole composition.
Materials	60 × 80cm (23½ × 31½in) painting canvas, acrylic paint, fine painting brush, palette knife.
Technique	Scraping, glazing and writing techniques.
Work sequence	Go and find a text or poem that suits your mood. 'Write' it on the canvas with a fine painting brush using acrylic paint (A). Choose your colours and apply them using the palette knife. Use the side of the knife and scrape another thin layer of paint on to the canvas and then mix the colours into it. Take care that the text remains visible in some way (but it should not be dominant). In order to absorb the imagery of the text even better, the work should finally be glazed.
Tips	The acrylic paint can be thinned with an acrylic medium or binder in order to obtain glazing which is free of stripes.

B *Acrylic study on paper*

Variation exercises

1. Also try the opposite work sequence. First apply the colour, then the text and afterwards the glazing. If the text is still too strong the glazing can be repeated with thicker paint.
2. Of course, text can be processed in many different ways. Try the following: apply a layer of polychrome paint to the canvas and, using a sharp instrument, scratch arbitrary words or letters into the layer while it is still wet. Let it dry and glaze the whole thing (B).

Right-hand page.
A *Acrylic on canvas 60 × 80cm (23½ × 31½in) (C. Ruyters)*

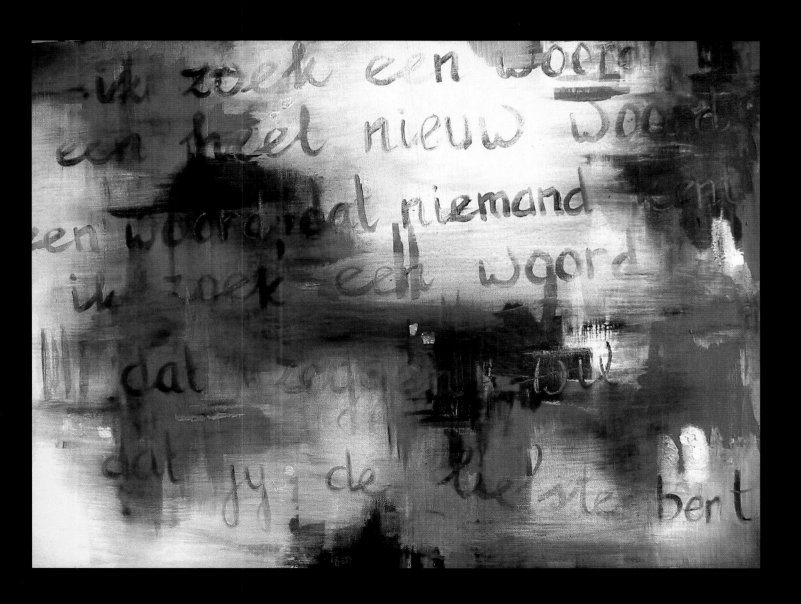

Exercise 57 Explore alternative techniques

Theme/ emphasis	Playing with line and colour.
Picture elements	Line, colour, shape, texture, contrast, tone, rhythm, design, harmony, variation, unity.
Composition	No preliminary composition is made. A colour design which fills the picture will evolve during the work. It will have the same overall intensity and strength. There are no passive areas.
Materials	Acrylic paper, acrylic paint, sponge, fine painting brush, stiff straw.
Technique	Blow, splash, flow and glazing techniques.
Work sequence	Put all of the colour liquid in a glass. Lay out the paper fully horizontally. Let some thick drops run on the paper and, with a straw, blow the liquid paint to each side, therefore making a fantastic line design. Repeat the action with a second colour. Then a third colour. While the paint is still wet the colours will mix on the paper. Use a brush now and again to splash paint on to the paper. Finally, let everything dry and then glaze the whole thing using a sponge and transparent paint.
Tips	When the colours are allowed to mix, begin with the lightest colour. If the colours are not allowed to mix, let each layer dry before you apply the next colour.
Variation exercises	1. Now start with an even-coloured underpainting. Blow lines over it in a complementary colour. Splash some colour on it and paint it until you are satisfied. 2. Now begin with a black underpainting and only do the blowing and splashing with, for example, white, ochre and burnt sienna.

Exercise 58 Learn to recognise and use abstract shapes

Theme/ emphasis	Playing with reality as a surface divider.
Picture elements	Line, shape, colour, texture, size, tone, rhythm, design, composition, active, passive, harmony, unity, balance.
Composition	A type of composition in the form of a cross. Based on a photograph from nature, the fracture lines in the rocks are used as a play of lines and as a composition, with a central focal area, surrounded by passive areas.
Materials	Stiff drawing paper, coloured pencils.
Technique	Coloured pencil technique.
Work sequence	Find a photograph which will inspire you to make a composition. With a pencil make a composition as a result of the photograph. Colour the whole thing with coloured pencils. Use the point of the pencil for hard colours and the side to make soft colours. Draw the colours over each other as well to create optical mixtures.
Tips	Working with coloured pencils is a good way to make preliminary studies which we can later rework as a large painting. Instead of coloured pencils you can also use watercolour pencils, which enable you to mix colours with water.
Variation exercises	1. Do another exercise and now choose another photograph and finish it with felt pen. 2. This time take a large sheet of paper and use the composition of a photograph to make a large painting directly with paint. Allow the lines to be clearly seen as contours.

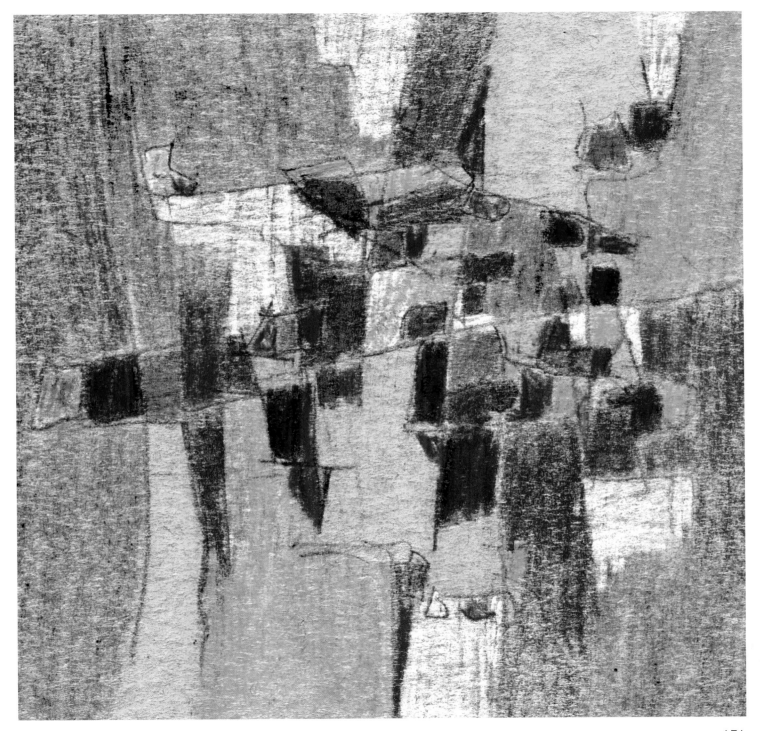

151

Exercise 59 Nature as imagery

Theme/ emphasis	Playing with leaves and printing technique.
Picture elements	Line, shape, texture, colour, tone, size, rhythm, repetition, design, contrast, dynamics, harmony.
Composition	No preliminary composition is made. The texture and prints will determine the composition and distribution of the shapes during the painting process.
Materials	Acrylic paper, acrylic paint, brush, dried leaves.
Technique	Rough a la prima painting and printing techniques.
Work sequence	Pour paint directly on to the paper from the tube or pot (A). Roughly stroke it in all directions with a large brush until the entire paper is coloured. Let this underpainting dry. Paint a leaf on its veined surface with pure paint and press it on to the base. Wipe over the whole leaf and carefully remove it. A print of the leaf will remain. Repeat this until complete prints have been made.
Tips	Always remember to make the print with a contrasting colour, for example a brown leaf print on a white base and vice versa. The print of a leaf is a little more exciting if it is only vaguely visible. This means that the leaf to be printed must not have too much paint and certainly not too much wet paint.

Variation exercises

1. Now start to make prints with leaves on a white base. Then glaze the whole work using transparent paint.
2. Make the leaf prints fill the picture and paint over it using thin watery paint, allowing the colours to run and mix into each other. This makes the prints appear blurred. Decide which parts you may want to paint out in order to create some calmness and texture.

Right-hand page centre.
Acrylic on paper 50 × 70cm
(19¾ × 27½in)
(S. v. Nostrum)

A

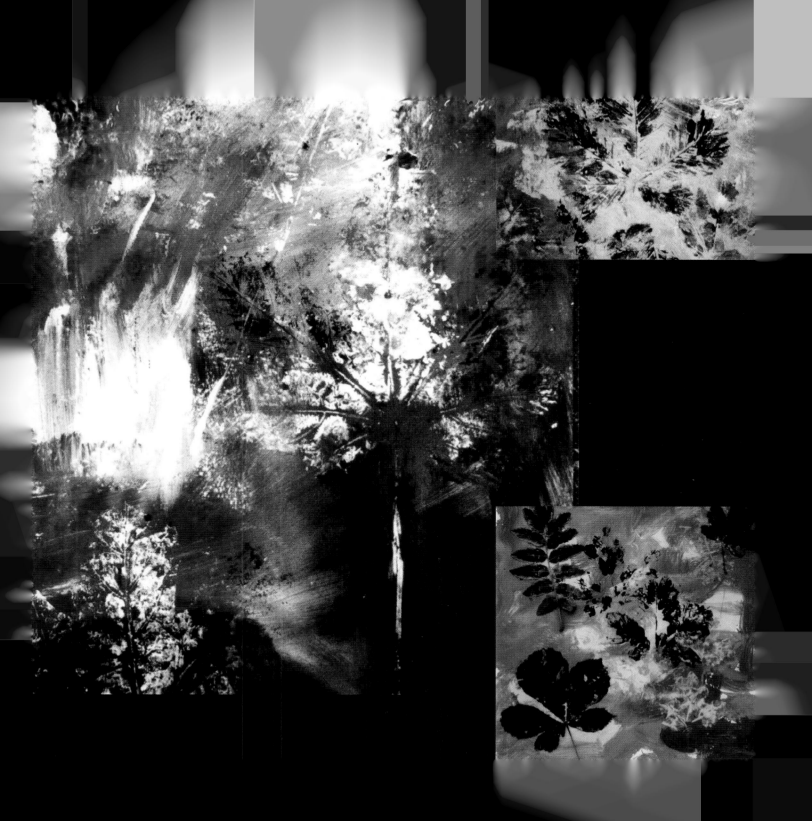

Exercise 60 Texture from beginning to end

Theme/ emphasis	Playing with texture and design.
Picture elements	Line, shape, colour, texture, tone, contrast, composition, equilibrium, harmony, variation.
Composition	Stage 1 is carried out without any composition. Stage 2 is a carefully designed composition with a central active focal area in the shape of a cross, with calm passive areas in the four corners.
Materials	Sheet of stiff drawing paper, 50 × 50cm (19¾ × 19¾in) painting canvas, acrylic paint, glue, brush, palette knife.
Technique	Texture techniques: dripping, splashing, blending and scraping, including collage and knife techniques.
Work sequence	Stage 1: apply texture to a sheet of drawing paper. Use watery paint in different colours, splash, blow, drip, rub and scrape it until the entire surface is full of colour and texture. Let it dry and, in the meantime, paint a base layer on to the canvas. Tear or cut the texture sheet into pieces and use it as collage material. Stage 2: design a well-balanced composition with active and passive areas with the pieces of paper and stick them on. Then continue painting with a palette knife and integrate the pieces of paper into the whole thing. Finally smooth out some areas with the brush.
Tips	Making up collage material yourself is amusing work where, in principle, you can use anything. In addition, you obtain more experience and are stimulated to experiment freely.
Variation exercises	1. Now take some acrylic paper and fill it up with texture experiments. Try anything that comes into your head. Rework it until you are satisfied with it and frame it. 2. Do another sheet with texture. This time that is your base. Cut out pieces of coloured paper and use that as collage material to cover parts of it. Finish painting the work where it is necessary.

Stage 1

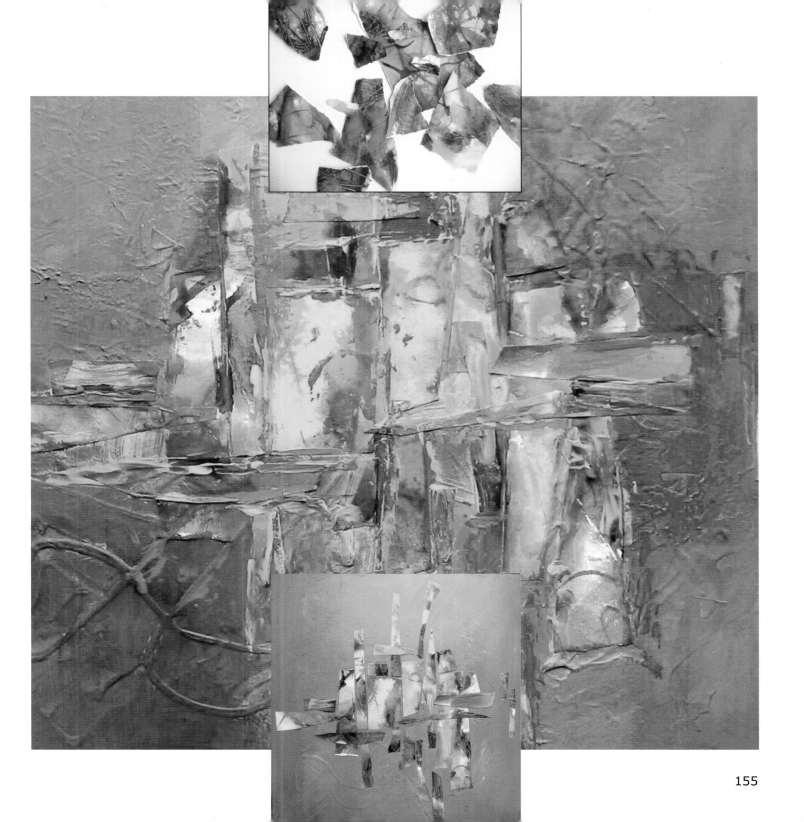

Exercise 61 Looking for collage material

Theme/ emphasis	Playing with material, texture and colour.
Picture elements	Line, shape, colour, tone, texture, contrast, size, composition, passive, active, balance, harmony.
Composition	The composition is only built-up with the collage materials which you have found. A composition in the shape of a cross and one in an 'L' shape are used in the examples.
Materials	Painting canvas, acrylic paint, glue, brush. In addition, various materials such as cardboard, dressing gauze, jute, string, lumps of plastic, raffia, etc.
Technique	Collage and integration techniques.
Work sequence	Design a composition with different materials. Arrange it until you are satisfied and then stick the materials on to the base. Then paint it with acrylic paint. Remember to use contrast and variation with regard to both colour and materials.

Tips

If you find these sorts of collages attractive collect as much suitable material for them as possible. Avoid sticking too much on to the canvas.
The material usually acts as a focus and so it makes sense to keep calm areas free from texture as well.

Variation exercises

1. Look for other alternative materials and use them to make collages. Always choose other colours and also use another size for the picture surface.
2. Now construct a collage with materials which only emphasise the picture element line. Think about sticks, string, raffia, etc. when you do this.

Collage on canvas 50 × 50cm (19¾ × 19¾in)
(T. Heukelom)

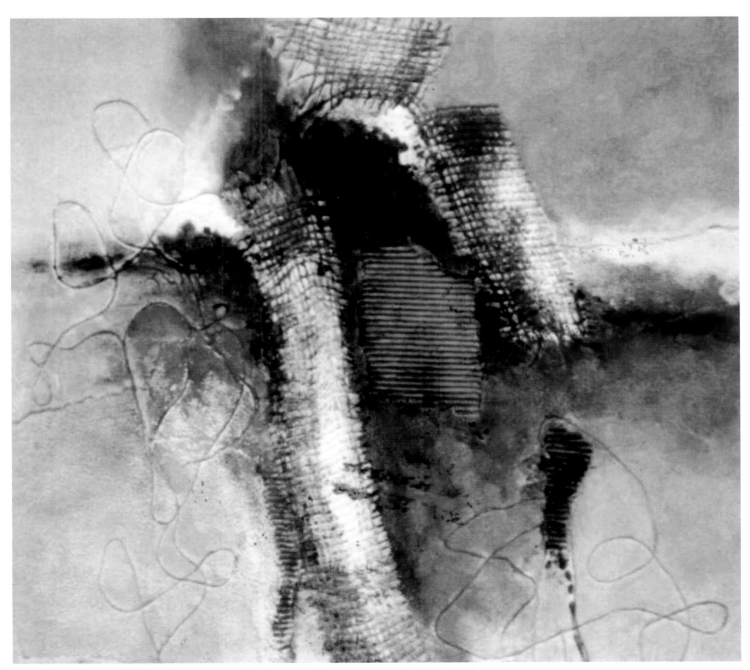

Collage on canvas 50 × 50cm (19¾ × 19¾in) (M. Niejenhuis)

Exercise 62 Abstract from reality

Theme/ emphasis	Playing with figurative shapes.
Picture elements	Line, shape, size, colour, tone, texture, composition, harmony, contrast, dynamics, abstracting.
Composition	A composition which fills the picture with lines running towards the outside and an active central focus area created by reducing the size.
Materials	50 × 50cm (19¾ × 19¾in) painting canvas, acrylic paint, sand, hard brush.
Technique	Texture technique.
Work sequence	Choose a realistic shape as a basis for the design. When you are putting your composition together remember the rules for abstracting. Using the shape, design a dynamic composition in which you pay attention to variation in size. Apply a base layer to the canvas using thick paint and scatter sand directly on to it. Let the whole thing dry thoroughly. Halfway through the drying process scrape contour lines into the composition with the back of the brush. Then colour the different areas. The sand will ensure a rough surface, with both tactile and visual texture.
Tips	If you mix the sand with the paint before you apply it to the canvas the granular effect will be reduced and it will thicken the paint. If you want a more granular effect scatter loose sand over it.
Variation exercises	1. Now find two different objects from reality and rework them together as the basis of the composition. Choose another technique for its execution. 2. Use the same technique once more and make a composition which fills the picture, in which the shapes run across the picture surface as a rhythm.

Trees *Bottles*

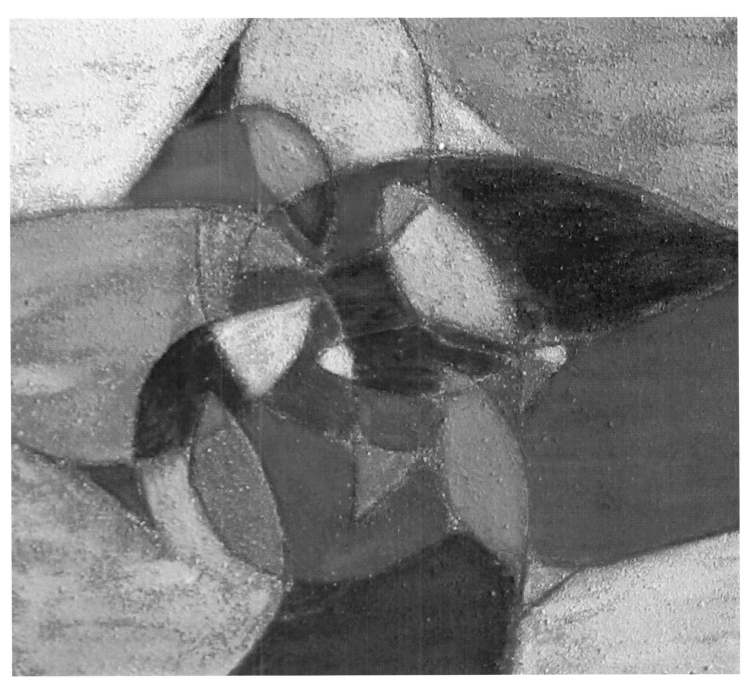

Fish. Acrylic with sand on canvas 30 × 30cm (11¾ × 11¾in) (M. v. Bethlehem)

Exercise 63 Design a painting

Theme/ emphasis

Playing with theme, composition and technique.

Picture elements

Line, shape, colour, tone, texture, size, contrast, harmony, composition, space, unity.

Composition

The composition consists of the grouping of a number of rectangles and squares which differ from each other in size. Each rectangle or square contains a second composition of its own into which is placed a part of the theme chosen by you.

Materials

80 × 80cm (31½ × 31½in) painting canvas, acrylic paint, brush, anything else needed for the techniques selected.

Technique

Design technique.
In making an individual design the appropriate techniques are decided in advance. Here a collage technique is used with a smoothly painted colour transition.

Work sequence

The execution of a design can entail taking a number of steps in which choices have to be made in advance with regard to composition, colour, composition, technique, etc. Making preliminary draft sketches can play an important part, certainly in a complex exercise such as the music theme here.
In a less complex exercise, a rough sketch will be enough, maybe in colour.

Variation exercises

1. Choose two other themes as a subject and complete them using different techniques.
2. Then use one of the same themes for a large work, a small work and a double panel. When it is finished you will be ready to have your own mini exhibition.

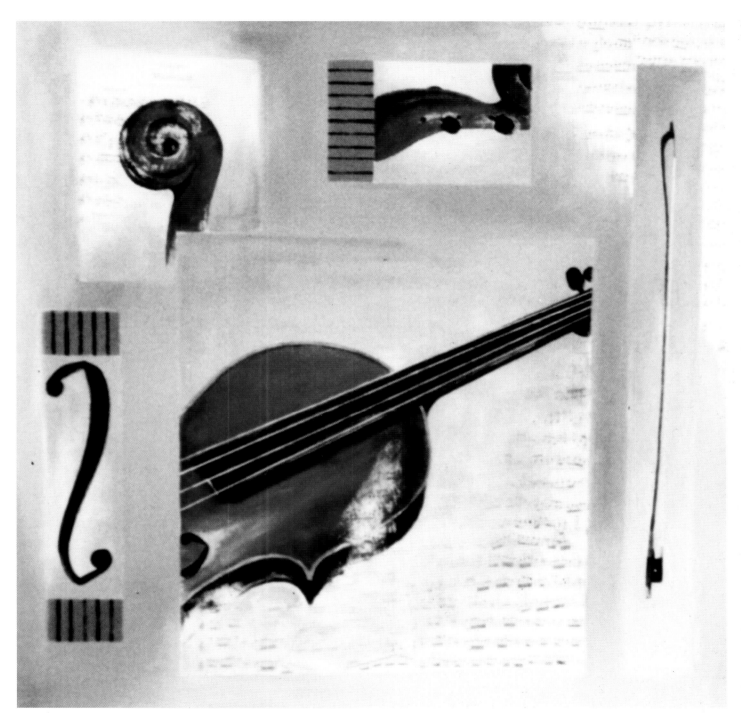

Mixed technique on canvas 80 × 80cm (31½ × 31½in) (C. Ruyters)

Exercise 64 Working with coloured paper

Theme/ emphasis

Playing with colour and texture.

Picture elements

Colour, shape, texture, tone, contrast, dynamics, harmony, unity.

Composition

No preliminary composition is made; this will evolve as a result of the collage technique and painting in which attention is paid to effects which can intensify the focal area.

Materials

50 × 50cm (19¾ × 19¾in) painting canvas, acrylic paint, coloured paper, glue, brush, palette knife.

Technique

Collage, knife and layering techniques.

Work sequence

Tear the coloured paper into pieces and stick them arbitrarily on to the base with glue. The canvas may also be coloured with an underpainting.
Apply pure colours with a knife. Take care that sections of the coloured paper remain visible and let mixtures develop randomly.
Repeat this process in order to build-up more texture.
Leave some areas free of texture to bring some calmness into the composition.

Tips

You can use circulars and leaflets for coloured paper. You can make it yourself by covering some sheets of paper with colour; you will then have more choices of colour and you can exercise your own preference.

Variation exercises

1. Cut out a number of circles in different sizes from coloured paper, stick them down and draw a contour line around them. Finish the painting by glazing and covering some areas with paint.
2. Now do an exercise in which you use coloured paper with only neutral tones, for example different tones of beige, grey, cream, etc.

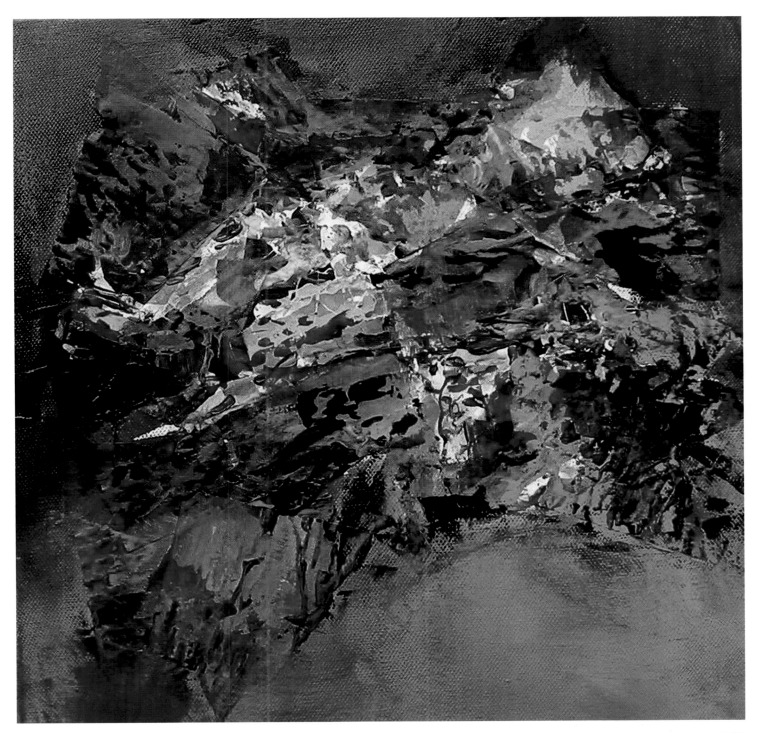

Exercise 65 Design like Picasso

Theme/ emphasis	Playing with violations in shape and composition.
Picture elements	Line, shape, colour, tone, size, composition, rhythm, harmony, unity.
Composition	A composition which almost fills the picture, with vertical emphasis compensated by horizontal and diagonal lines.
Materials	Paper, pencil, 80 × 80cm (31½ × 31½in) painting canvas, acrylic paint, brush.
Technique	Direct smooth technique with pure clean colours.
Work sequence	Find a theme which you want to use for this design technique. It can be a still life, a landscape, flowers, a portrait etc. Draw the subject in contour (A). Then cut the drawing up into pieces and make up a new composition (B). Move the pieces about in relation to each other, let them overlap or put them in an entirely different place. Stick the pieces in the new combination on to a piece of paper and continue with this design (C). Put the newly designed composition on to the canvas in pencil and use a heavy contour line. Paint the work in colour.
Tips	Cutting up and regrouping a basic drawing is an amusing puzzle which can give rise to surprising compositions. The way in which the displacements are made decides whether the resulting work will remain figurative or become more abstract.
Variation exercises	1. Use the same composition technique in an already abstract composition and use a free painting technique for its execution. 2. Take one of your old figurative studies and cut it up into pieces in order to make a new composition from it with the Picasso design technique.

A

B

C

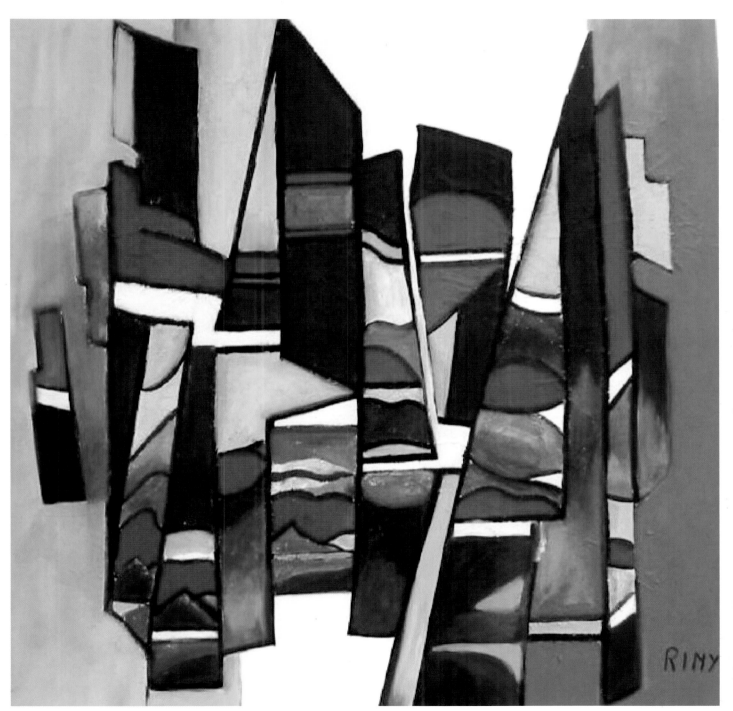

Acrylic on canvas 80 × 80cm (31½ × 31½in) (R. v. d. Valk)

165

Continuing independently

The exercises described in this book will have given you the opportunity to develop your painting skills. In any case, they will have stimulated you to paint expressively in the future.

Doing the study exercises is a step in the right direction, but you should also carry out projects independently. In this way your work will be original and individual.

It is now time to try to stop relying on the lessons from this book. Now that you have been introduced to abstract painting and its tools, you can go on and discover new themes. Your experience of picture elements, types of composition, surface division models, different materials and many techniques for reworking the material form a basis on which to build.

However, there are certain times when every student requires assistance! Try to find a teacher or a mentor who will be ready to discuss your work with you and, where required, assist you on your way.

A few more tips to help you on your way:

Tips

- Do all the exercises in the book again and in each exercise invent your own variation exercise. In this way you will have 65 new exercises. Note them down in your own book of ideas.
- Then go and find other materials and do more experiments. Study the different materials and techniques in the book once more.
- Make up your own book of ideas and write down all the themes and subjects which you can think of. I guarantee that they will provide you with many ideas to paint.
- Visit exhibitions and displays and be inspired. However, in doing so, suppress the tendency to want to copy works which you have seen.
- Take photographs or make sketches of the things which you see around you and try to view your environment in different ways. Learn to see 'abstractly' and discover rhythms, contrasts in colour, shapes, compositions, etc. which one by one can be an excuse to go and paint.
- Join a painting group or, if necessary, a group of painting friends to work with. This can be very stimulating and fun.
- Be open to new ideas.
- Cultivate a healthy curiosity and desire to experiment and experience the pleasure that free and spontaneous painting can give you.
- Always aim for creativity, expression, originality and individuality and be led by your own talent.

Go ahead and enjoy it!

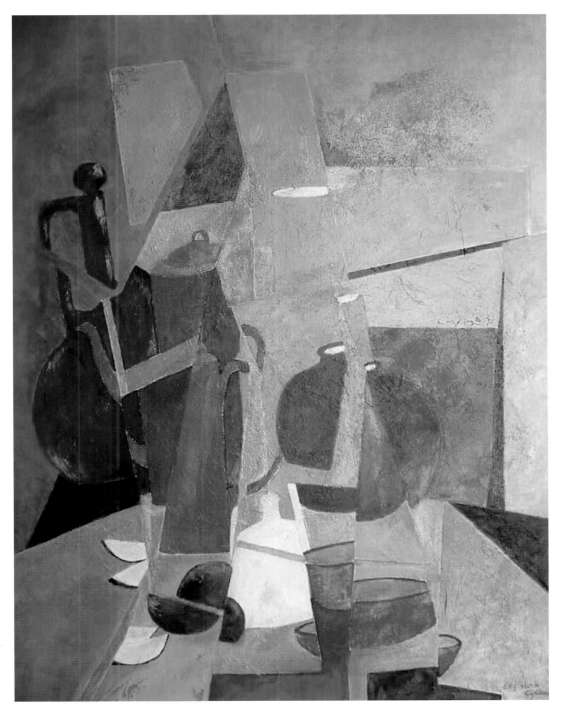

*Design like Picasso, see Exercise 65. Acrylic on canvas 80 × 100cm
(31½ × 39¼in) (E. Wateler)*

In conclusion

The abstract method and the lessons explained in this book are all designed by me. They are reproduced from my experiences as a visual artist and as a teacher. In addition to the illustrations of my own work there are many by members of my courses. I should like to thank them for making their work available; it has helped to make this a very varied book.

I wanted to help you to develop a more challenging way of painting. It is of no importance whether you are now a fan of the abstract or simply of the figurative. Your acquaintance with the abstract method of painting has shown you the way to yourself, your inner being, your own talent. I hope that along the way you have discovered and experienced the essence of free painting.

I wish you much success.

Rolina van Vliet

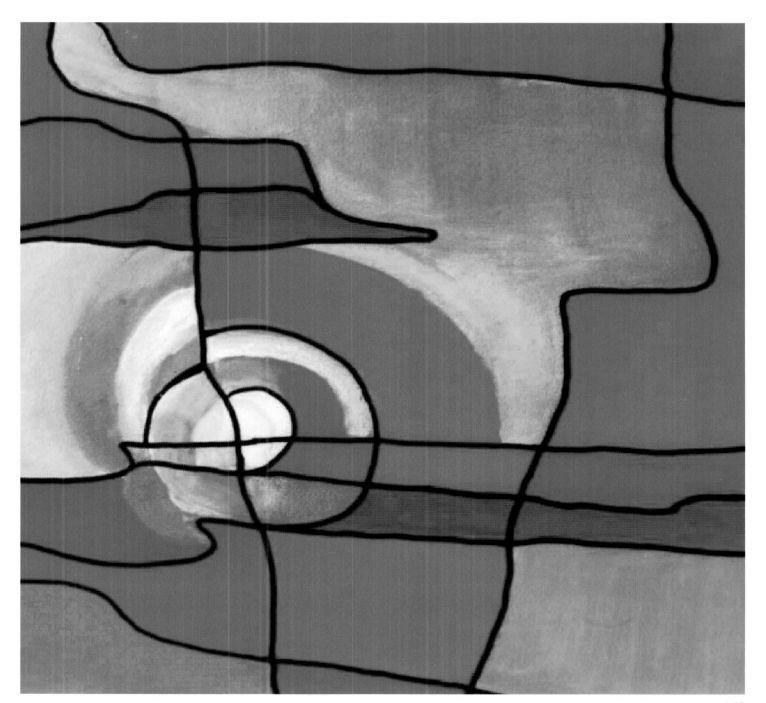

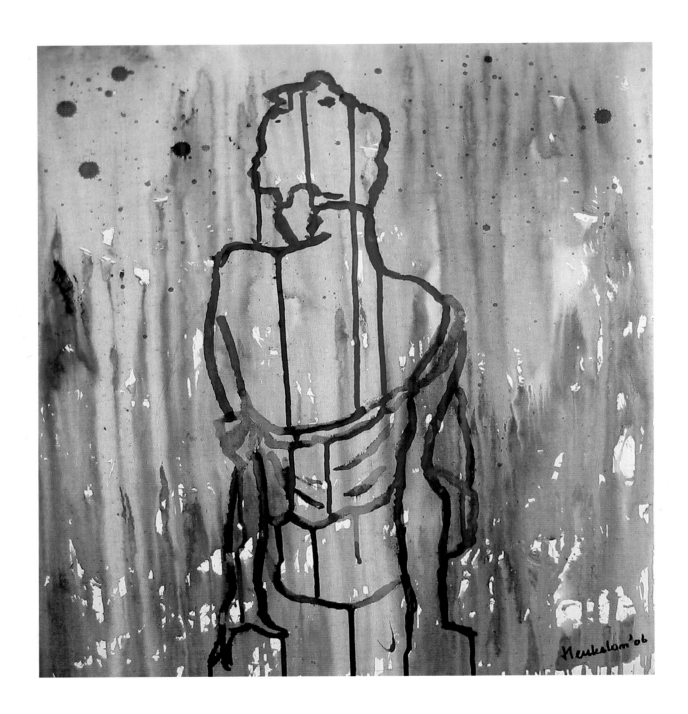

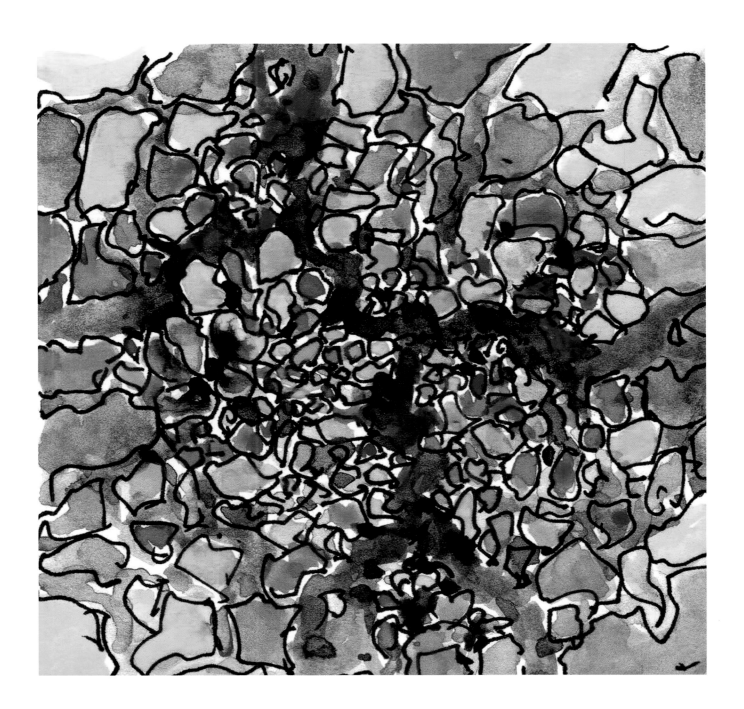

172